IMAGES OF ENGLAND

CLEVEDON

IMAGES OF ENGLAND

CLEVEDON

JANE LILLY WITH DEREK B. LILLY

TEMPUS

First published 2007

Tempus Publishing
Cirencester Road, Chalford,
Stroud, Gloucestershire, GL6 8PE
www.tempus-publishing.com

Tempus Publishing is an imprint of NPI Media Group

© Jane Lilly with Derek B. Lilly, 2007

British Library Cataloguing in Publication Data.
A catalogue record for this book is available from the British Library.

ISBN 978 07524 4375 1

Typesetting and origination by NPI Media Group
Printed in Great Britain

Contents

Acknowledgements

For photographs: private collectors who prefer to remain so – thank you. Also Tony Bracey, Clevedon Heritage Centre, Barbara Connell, Doreen Cooke, Phil Ellis, Norman Fisher, Peter Ganniclifft, Iain Gray, Frances Hardcastle, Rose Hughes, David Knight, Mr J. Knott, Derek Lilly, David Long, Ray Lumbard, Denis Moxham, Peter Neads, Bryan Osborne, Graham Osbourne, Alison Peacock, Peggy Price, Les Reed, Georgina Rose, Mark and Tracy Saunders, Mary Seeley, Betty Smith, Don Sulley, Patrick Tossell, Veronica Wainwright, Mr Warburton and the late Dave Wood.

Special thanks to my devoted proof reader. I offer heartfelt gratitude to the person who invented the 'undo' button in the Word program and whoever thought up Google. To Alex Hardy – grateful thanks for the technical help.

For information: Derek Lilly's bottomless archive, Alan Blackmore, David Bryant CBE, Rob Campbell, Peter Neads, John Niblett, Joan Osborne, Alan Rome, David Shopland.

Introduction

My own introduction to local history came by way of my uncle, Derek Lilly. Derek's enthusiasm together with our joint archive has been a tremendous help to my researches and without his assistance on the IT front neither this book, or my previous books, would ever have surfaced.

Assembling the photographs has been very rewarding and I have many helpful people listed in the acknowledgements. Clevedon is a friendly place and I have had terrific support both from locals and those who have wholeheartedly adopted the town. The Local History Group members have been a joy to be with – we all think local history should be something that is fun. If you are thinking of joining the group, don't think twice – come on in, the water's lovely!

We owe an enormous debt to the 'Unknown Photographer', as well as to local artists. The early photographs of Clevedon show us a lot we would otherwise not know about, often incidental to the subject of the picture. Hence, a long-lost farmhouse turns up beyond one of Knowles & Cox's wagons. In one of the views taken from the edge of Hangstone Hill the first Nonconformist chapel peeps out from behind St John's church tower. Prospect House in Highdale Road, incidentally the first house built on Clevedon Hill, can just be seen without the present shop built onto the side of the house.

The agricultural past surfaces through photographs found in attics – two showing Hillview Farm and Tutton Farm came from the owner of Hillview Farm who one day answered the door to a man from Kingston Seymour who had found them in his aunt's loft and was trying to find the houses themselves. Working life on the small farms created after the First World War can be seen in the photographs of Lower Farm, kindly offered to me by new friends. Much of the atmosphere of their time is preserved in these photographs.

Clevedon seems to have inspired people to record the passing of its cottages, many of them lost during the 1960s to new development. A Victorian photographer, a boy in the 1960s, local enthusiasts – all these have contributed to the pages recording these simple houses. Because of this, cottages rebuilt or altered can be revealed as they had been previously.

Many of the grand houses have become hotels, or were originally built with letting in mind. Postcards and advertisements have been a valuable source for these houses – as well as engravings and drawings. As more people travelled here to stay, leisure took on new significance and the Green Beach expanded along the coast towards the new hotel at Salt House during the 1920s, culminating in the building of the Marine Lake and its opening in 1929.

Local firms thrived, from the many one-man milk rounds to the organ factory and from Millcross to the Clevedon and Portishead Steam Laundry. Shops supplied every want and one hardly needed to leave the town 100 years ago, for clothing, household goods, furniture, exotic foods or almost anything else! Servicemen returning from the First World War having trained as mechanics, set up garages or motorcycle shops: we kept up with the times as fast as we could.

From Clevedon Court, encouragement and land was given for open spaces, schools, the hospital and churches. The Eltons produced a notable potter in Sir Edmund, who in turn instigated the formation of the fire brigade and gave, like others of his family, long service to the local council.

As the town grew, more religious denominations built their meeting places here. The sheer variety of architecture is fascinating to see, from Classical and Gothic to the new, some say rather controversial, Baptist church in Queen's Square.

For many people, sport has become a kind of religion! I am not one of these, but sport has never been lacking in the local calendar. Our best-known currently famous person, the ever-urbane David Bryant, has been many times world champion in the field of bowls. As well as this quiet pursuit, football, skating and many other activities can be found represented in these pages.

Recently the Golden Jubilee and the Millennium have been commemorated: in the past, we were given the Triangle Clock to mark the Diamond Jubilee of Queen Victoria. This is still with us. The town's other public timepiece stood at Sixways, quietly defrauding the town of time with its pendulum struggling against the water of a hidden dewpond, poor thing. Like the track of the Weston, Clevedon & Portishead Light Railway, this was given to the war effort, though not without local comment, as you will see in the relevant section.

The Bristol Channel is noted for its tidal range, second only to the Bay of Fundy in Canada. This, combined with low-lying land has often produced disastrous results for our sea front and the 'Unknown Photographer' has bravely recorded the highest tides in the classic 'Rough Sea at Clevedon' postcards. As an alternative to these, I have been able to use some wonderful scenes of heavy snowfall, now so unusual. Damage done by rough seas at 'The Beach' turns up more than once, due to local photographers with their keen eye for public interest.

Change of all kinds continues in our town, much of it good. So I would enter a plea here to anyone who wants the Pier (the only listed Grade 1 Listed pier in the UK), the Heritage Centre, the Curzon or the Marine Lake to continue in use, to support these projects. Please, help if you can. Many thanks!

one

Our Town

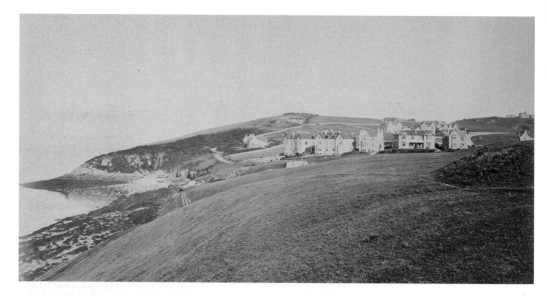

Above: Walton St Mary, shown in the 1870s, has been part of Clevedon since 1932. It was developed after the Miles family gained access from the end of Clevedon's Wellington Terrace to their land, in the mid-1850s. On the photograph's right-hand edge is St Margaret's in Channel Road. The houses in the centre are in Bay Road with Edgehill Road houses peering across the rooftops. Ladye Bay is to the left.

Below: The earliest part of Wellington Terrace was named after the Duke of Wellington, who was Prime Minister from 1828 to 1830. The largest building is the Edgarley Hotel, with terraced gardens and gazebo. Adjoining is the taller Clevedon Hydro, a hotel much used by convalescents. Both have been replaced by flats. The quarry opposite the Edgarley provided the stone for building houses in the terrace, and then a site for more houses.

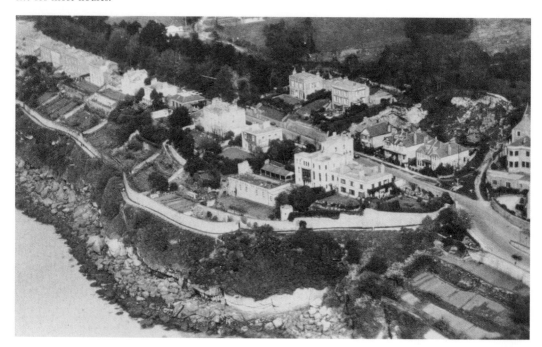

Right: This lower esplanade from The Beach to the Green Beach was laid out in 1867. The sea defences were still pretty primitive at this time. To the left is The Towers, now Campbell's Landing, with the York Hotel and Royal Hotel on the crest of the Hill. The Royal Hotel has gone, but the York Hotel remains in Marine Hill.

Below: A view of The Beach before the leaning hawthorn by the railings was pronounced dead in 1881 and removed. The railings were put in place after the lower esplanade was laid out, and The Beach is similarly fenced. The Pier looks rather flat here without buildings on the end; they came following the rebuilt pier head in 1893.

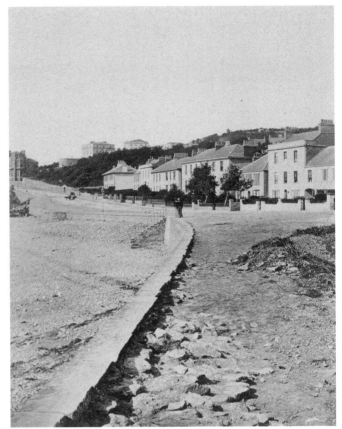

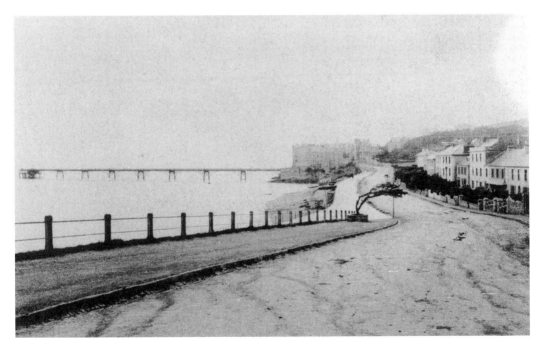

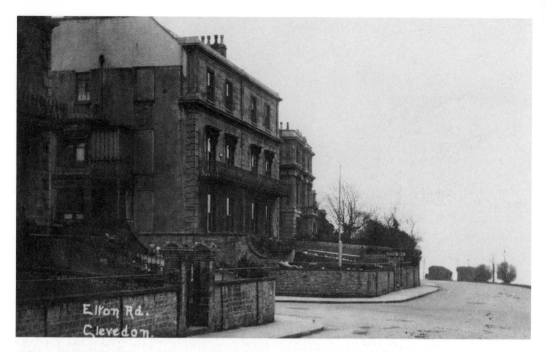

Osborne House and Richmond House in Elton Road can be seen here with balconies stretching across their front elevations, allowing open air views of the Channel. C.S. Lewis, the author of the *Narnia* books, stayed here several times in the late 1920s, in a flat owned by a friend, and seems to have enjoyed the walks and countryside around Clevedon enormously.

Opposite above: This photograph of Hill Road dates from the 1860s. The low castellated building on the left is at present being renovated after many years of neglect – it is No. 73, built as stabling for Eldon Villas Nos 1 and 2, glimpsed just above. The stables have a yard in the front. The ladder to the right could perhaps indicate alterations being made to the row of three shops at Nos 75-79.

Opposite below: This watercolour dates from 1895, painted from a footpath on ground given to the town by Sir Edmund Elton. The house to the right is in Jesmond Road, facing out across Hangstone Quarry with wonderful views across to Old Church Hill and the Welsh Coast. The Mendips are to the left of the artist with Clevedon Hall, Mr Finzel's mansion of 1853 seen in the middle distance.

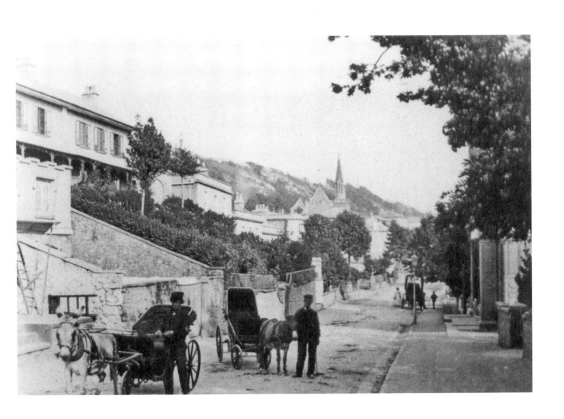

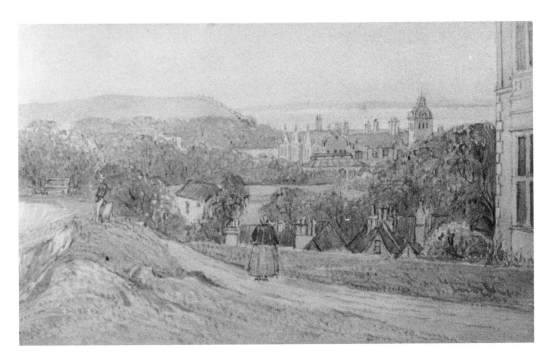

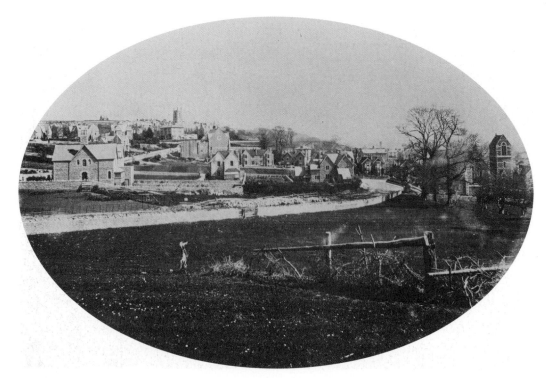

From above the small quarry that contains St John's Avenue, this was the outlook in the mid-1880s across to Christ Church. Belmont stands below Christ Church, with the gable of the Methodist chapel in Lower Linden Road to the right. The large pair of houses on the left is in Sunnyside Road; Queen's Road is between us and the Methodist chapel. St John's tower is to the right.

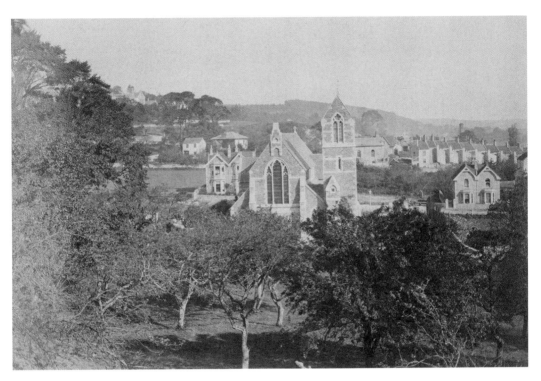

From the edge of Hangstone Hill the photographer has a more open view towards Christ Church. There were few houses in Queen's Road in the mid-1880s, and nothing from there to Chapel Hill. The small white house and the Regency building to the left have been demolished long since: this was Knapp House and its outbuilding. Western Court flats now stand there. To the right of St John's tower is the United Reform chapel that named Chapel Hill. The terrace descending was built in 1855.

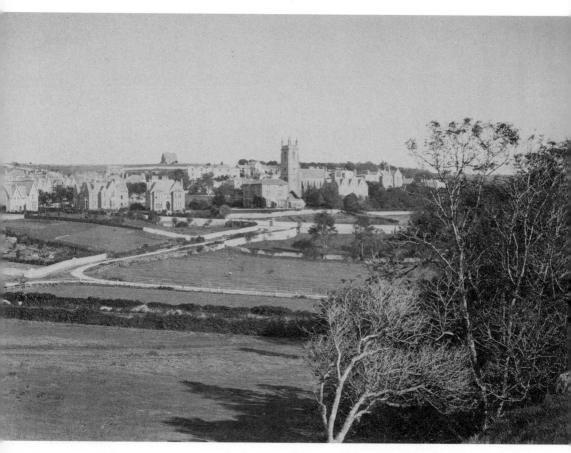

Still taken from the same point as the previous photograph, but looking a little further north, the photographer has here captured Clevedon as a building site: a very instructive photograph of a developing rural area. The house on the horizon is one of the Victorian lodges of the park in Dial Hill Road, while the houses below and to the right of it form Park Road. Behind Belmont, left of Christ Church, we can glimpse Prospect House in Highdale Road. There is no sign of the baker's shop built onto it in the late 1870s, now selling fitted kitchens. Below the lodge on the horizon is Rocklands in Lower Linden Road.

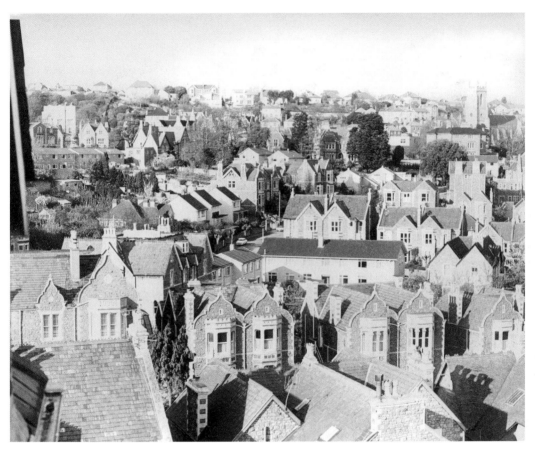

This view was taken by a visitor to the top floor flat of The Crags, at the east end of Jesmond Road. It replicates the previous photograph almost exactly, excepting in that it was taken about a century later. Though Clevedon architecture in this area is predominantly Victorian, a surprising amount of modern housing has been tucked into little pockets of what were private gardens.

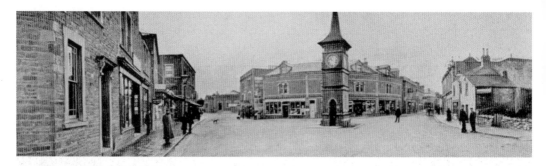

Above: The Triangle Clock marks the Diamond Jubilee of Queen Victoria in 1897 and is decorated with Eltonware tiles and columns made at Sir Edmund Elton's Sunflower Pottery at Clevedon Court. This was taken in 1903, and how the view has changed now – plate-glass shop windows, no station in the left distance and the cottages to the right replaced in the 1920s by shops.

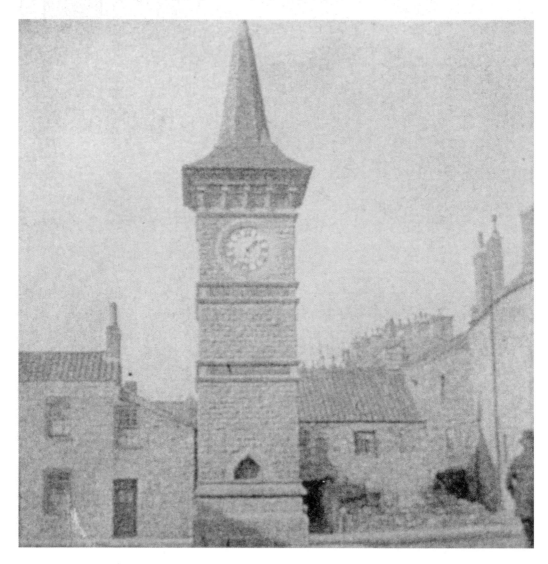

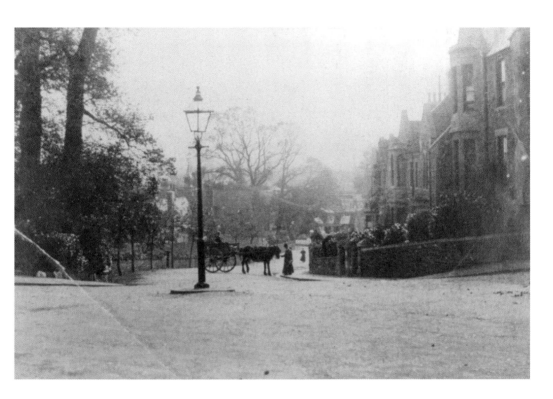

Above: A few of these trees are still growing here today in Hillside Road. To the right is St John's Avenue leading to the zigzag path to Hangstone Quarry. Looking down this road today, you would have a good view of the Curzon cinema, built as the Picture House and opened in April 1912.

Right: Taken from Dial Hill this photograph of the 1920s shows just how little building there had been around Kenn Road up to this time. Christ Church stands in Highdale Road, which runs along the edge of the Old Park on Dial Hill. Being on high ground, these roads had building plots with unobstructed outlooks to the Mendips, and over the Channel to Wales.

Opposite below: This view of the clock shows the demolished cottages more clearly. They stood on part of a farm called Morgan's, leased to John Griffin in the 1830s. The left-hand building was a shop, as yet unidentified, which stood beside the Triangle Club.

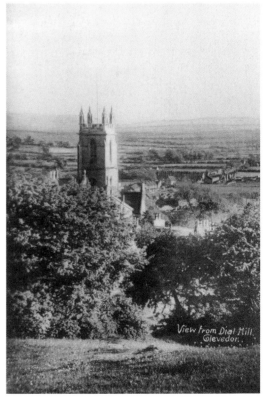

View from Dial Hill, Clevedon.

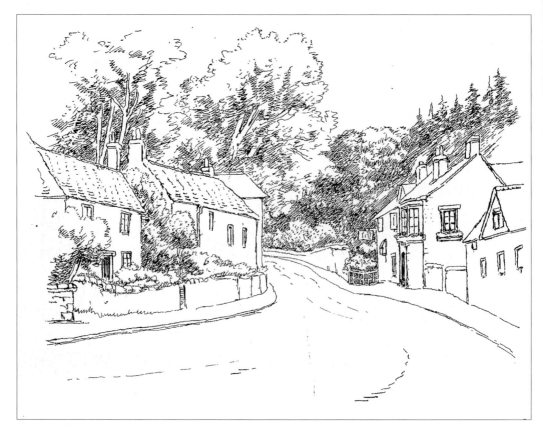

On descending Highdale Road from Christ Church, you would come to East Clevedon Triangle and the Walton Road. On the right is the Old Inn, still with its swinging signboard and bay window. The inn was first licensed in 1758, the oldest in the town. The cottages opposite date mainly from the 1780s and 1790s.

Opposite above: This is Dowlais Farm in Lower Strode Road. The present house was repaired by Edward Sesse of Kingston Seymour in the 1720s, but stands on a site dating back to at least the late 1400s, when William Sporyer held it from the Abbey and Convent of St Augustine along with an adjoining house. The name of the farm comes from a man called Dowles, who leased it in the late seventeenth century.

Opposite below: In the Clevedon Court Estate sale of 1919, Dowlais Farm in Lower Strode Road was sold and the land was divided to form new farms providing employment opportunities and housing for soldiers returning from the First World War. This particular one is Lower Farm in Lower Strode Road. The others were Dowlais Cottage, Clanna, Hayes, Dorsal Farm and Stileway Farm in the same road.

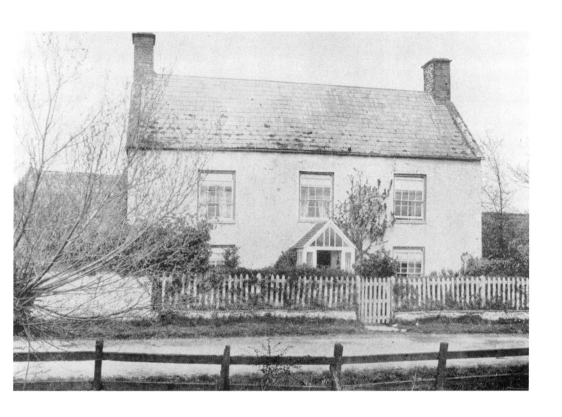

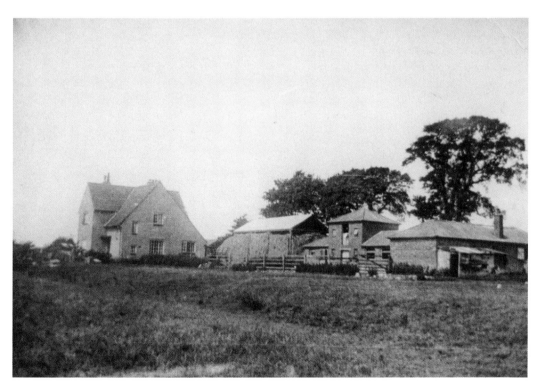

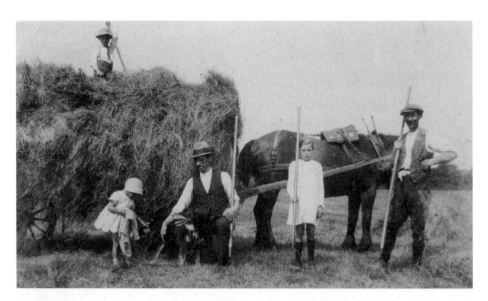

Hard work in the late 1920s, but it looks idyllic to us in these motorised days. Bill Griffin is on top of the hay and on the ground, left to right, are his sister Betty, Mr Charlie Clayton kneeling down with the dog, Scottie, Dolly Clayton and George Griffin, standing at the end.

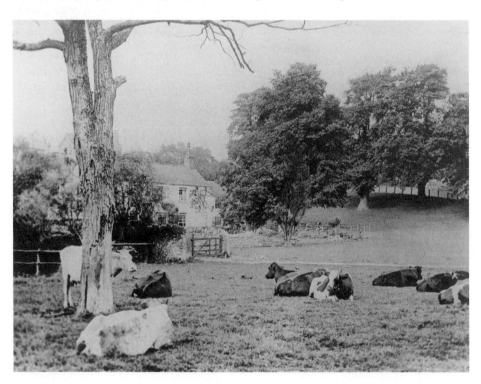

The Strode family built Strode Farm in the late 1600s. The Bullock family owned it later and an inventory of 1736 listed such luxuries as silver worth £124. The goods included the customary cider mill along with a less usual malting mill. The cows are lying on ground where West Way was built in about 1970. The farmhouse is now in West Way, whereas before it was in Old Church Road.

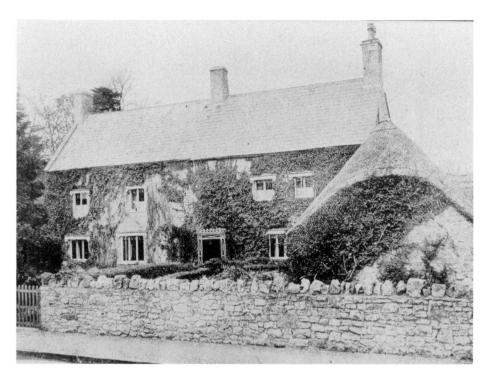

Salisbury Farm was also on Old Church Road, but became derelict, and demolition followed in the 1960s. It was named after Colonel Thomas Salisbury, who married the daughter of one of the Percival family, the farm being part of her marriage settlement in the 1660s. In 1919 the Tinklin family ran their successful dairy farm here, selling their milk and cream at No. 132 Old Church Road, formerly a shop.

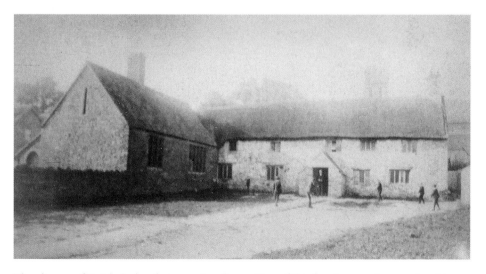

The glimpse of St John's church tower gives the position of this farmhouse – it was replaced by a new building for St John's School in 1889, which is now the library in Old Church Road. Here the school had not long moved into the old farmhouse in the mid-1870s and would have still been known locally as the Barn School.

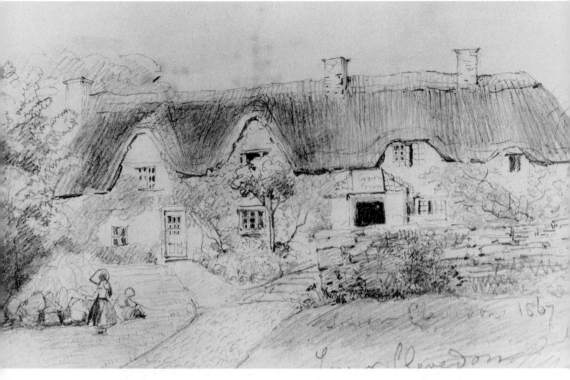

Beside the present library is a row of shops built in the 1870s by the Hollyman family. The shops replaced this farm called Childs and Mainstones that they had bought in 1704. When this drawing was made in 1867, part of the property was a beerhouse called the Crown. After demolition, the licence moved with the landlord, William Hancock, to the Forester's Arms on the corner of Lower Queen's Road, now the off-licence.

Opposite above: Taken in 1975, this shows Wrangle Farm, which stood on a site cleared for housing to the south of Ettlingen Way. In 1871 Edward Parsons worked 36 acres here. He learned his agricultural skills with his aunt, Elizabeth Crease and married Eliza, who was the daughter of Henry Newport, the Clevedon Court Bailiff. Ten years later he had 60 acres and employed a man to help, in addition to his sons.

Opposite below: Tutton Farm was in Moor Lane. It was demolished in 1975, when a survey recorded that the central chimney belonged to a medieval fireplace, with a magnificent arched stone doorway beside. The medieval part of the house is under the remaining thatch. The lady is Mrs Peacock, who farmed here with her husband William in the 1920s.

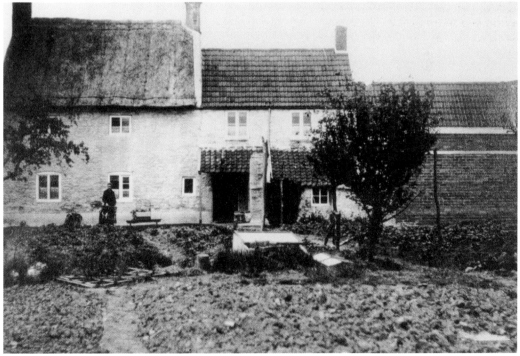

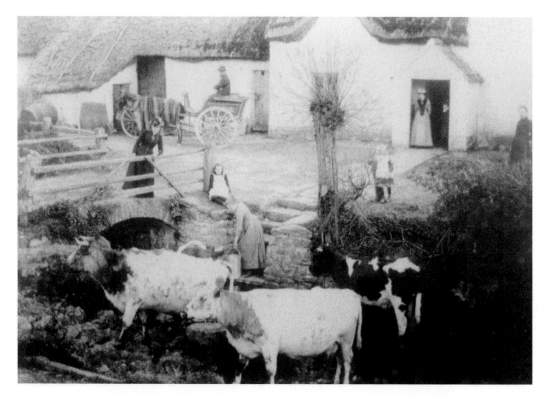

This is Tutton Farm from the north side with the Land Yeo River flowing alongside. The name came from the man who leased it in 1700, John Tutton. The photographer who took this photograph around 1890 obviously had an eye for the picturesque! Everyone is carefully posed: the girl on the river steps, the lady on the bridge – even the cows seem to know what's expected of them! There are cider kegs on the left. The cows would have walked in and out of the river down a slope, locally called a 'drink'.

Opposite above: Off Hill Moor is Hillview Farm which has been well restored. Recently the house was examined by English Heritage and is believed to be a partly medieval building. Recent study of Court Rolls for Clevedon has drastically revised local knowledge of land use in the fourteenth century, and this could be one of the farms recorded in the Rolls.

Opposite below: Newhouse Farm on Moor Lane will look familiar to visitors and locals alike, having been Clevedon Craft Centre for many years now. The house was rebuilt by Sir John Knight, Lord Mayor of Bristol, after the previous building burned down between May 1629 and May 1630. He was a rich man, a fact reflected in the size of the house, which is just over 70ft long!

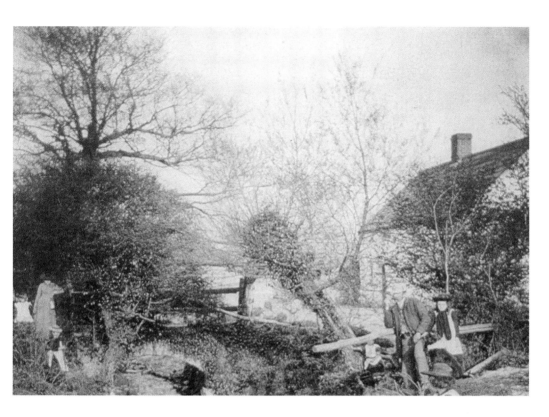

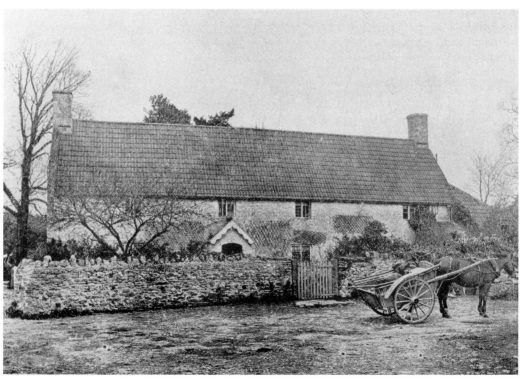

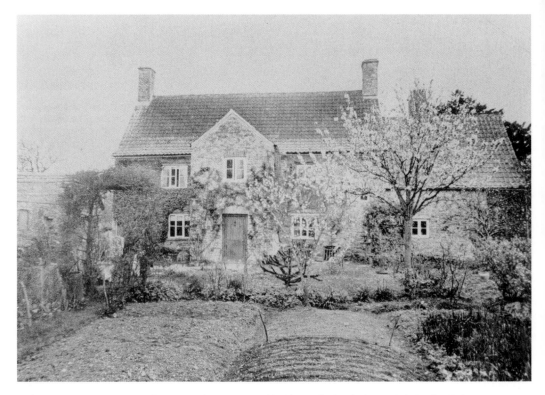

Cole House Farm was part of a manorial estate owned by the Cole family (now Coles). The Coles were in a land dispute during the thirteenth century with the Pike family – both families are still in the town. The house is in Cole House Lane, which runs between Kenn Road and Strode Road. The estate was managed from the manor house, now called Lake Farm, in the same lane.

Opposite above: This is Park Farm portrayed by local photographer Edwin Hazell in 1903. It was built by the Eltons on Dial Hill in the 1850s and seems well established fifty years on. This part of Clevedon was undeveloped until the middle of the nineteenth century due to a lack of surface water in this area.

Opposite below: How isolated St Andrew's church appears to be in this photograph, taken long before the building on St Andrew's Drive. There is still a footbridge here, leading to public open ground by the sea wall. The white house to the left is Church Cottage, built around 1820 as a row of dwellings. The tiled shed was cleared when St Andrew's Drive was built, but the Victorian house beyond it is still there.

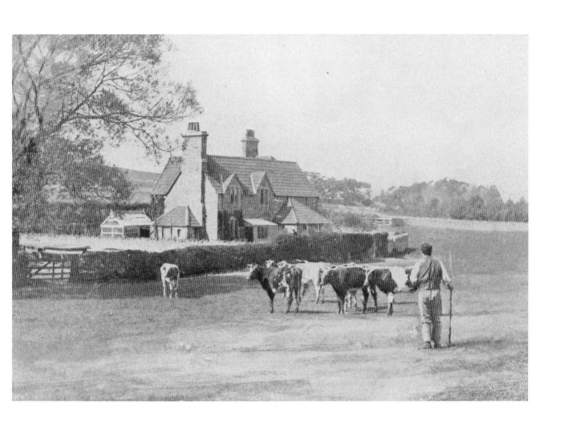

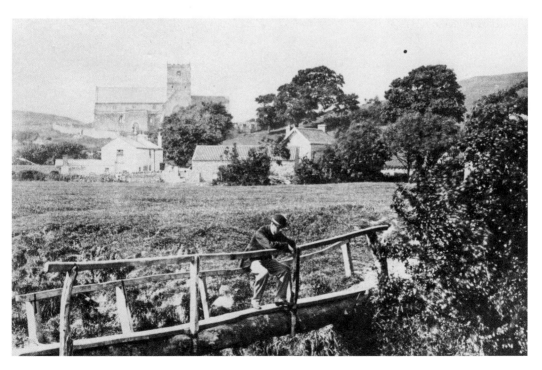

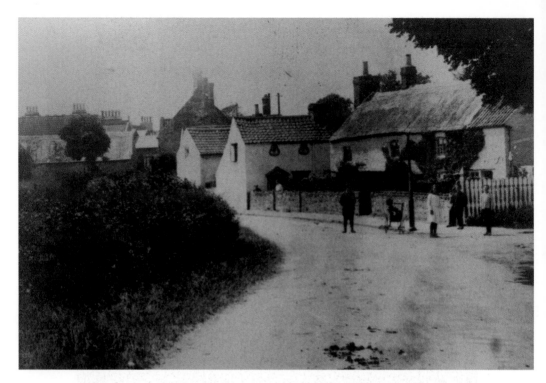

This gem shows Hack's Nest around 1910. The cottages were built by Jacob Hack in the 1830s in Old Church Road by the entrance to Salthouse Road. The one with trefoil windows belonged to Stan Newton, projectionist at the Picture House (now the Curzon) for fifty years and known as 'Stan the Man'. He called it Shamrock Cottage – it's the only one that hasn't been rebuilt. It was the smallest cottage in Clevedon.

Opposite above: The builder of this cottage at No. 81 Old Church Road didn't bother to buy a plot from the Clevedon Court Estate; he built on common land! The land is Hangstone Quarry, and the quarryman was William Vicarage. He built this house next to his own as two cottages in the 1830s. A fire destroyed most of the left-hand house at some time, but it has been restored since.

Opposite below: This is on the south side of Old Church Road. Beyond the lean-to to the right, you can see the shed across the road in Hangstone Quarry where the council steam roller was kept. The house, converted from a farm building, was extended to make a tea room. Opened in the late 1960s as Cheung Chaw it is still running now. In 1972, you could buy a three-course meal there for 35p.

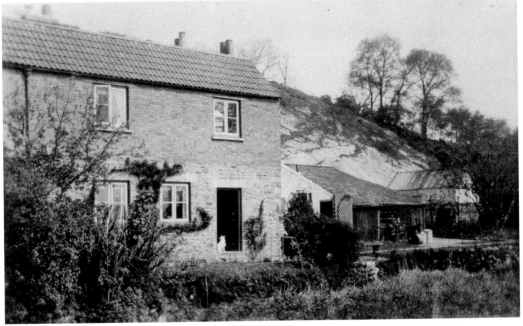

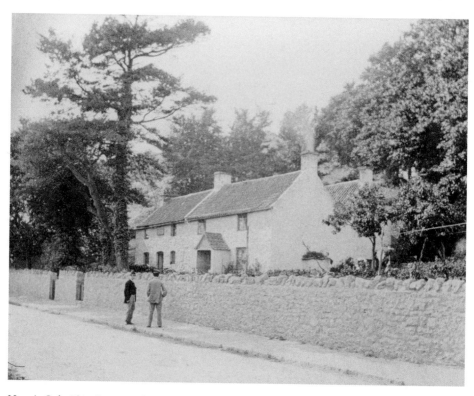

Here is Coleridge Cottage, at No. 55 Old Church Road. Little has changed even the porch is still there. A handsome marble plaque is on the house wall commemorating the poet's stay in 1795. Coleridge Cottage was originally built in the late seventeenth century with one storey and an attic, its upper storey being extended in the late eighteenth century, before the poet rented it.

In the 1960s some cottages made way for modern housing, and this was Nos 94 and 94a Kenn Road, now gone. It stood next to the Kenn Road Stores, seen to the left. Like most of the older cottages in Kenn Road, it stands on waste ground sold off by the Clevedon Court Estate after 1815, built by someone having pretensions to style, with its plain, parapet front.

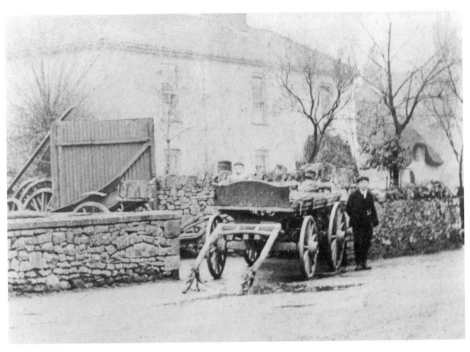

This is from a photograph taken around 1900 of one of Knowles & Cox's wagons. The row of cottages are Nos 139–143 Old Street. The thatched house to the right on the corner of Meadow Road has vanished. On a map of 1847 it is referred to as 'Brocks' and in 1607 Mr Brock lived here. In a lease of 1690 it was noted as 'roofless', and as such could not be lived in.

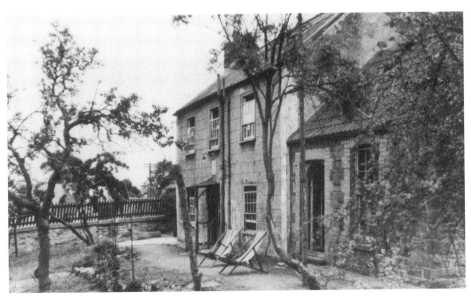

This cottage was built in 1792 in Strawberry Hill Lane, which leads from Walton Road to the Fir Woods. The builder was Richard Long, a butcher who supplied the meat for the Rent Feasts held by the Court Estate as late as the 1840s. For a while in the early 1900s, the vicar of All Saints lived here and the vicarage itself, near the church, was rented out to visiting families.

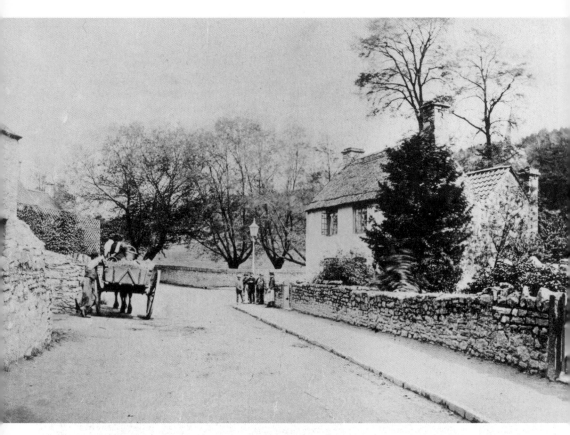

The gate to the right belongs to the end of Orchard Cottages in Walton Road. The house on the right here is Rawlings' cottage, built by John Rawlings in 1823 on manorial waste ground on the corner of All Saints' Lane. This cottage has since been totally rebuilt, with dormer windows and tiled roof. Harris's old forge is seen here to the left, with a cart outside. This forge was built after 1840, reflecting the increase in traffic through the old Village.

Opposite: Still in Walton Road, here is the gable end of Orchard Cottages to the right, built in the 1860s by Sir Arthur Hallam Elton. The coal cart belongs to Bill Anslow, a carter who lived in the nearest cottage with his wife, three children, mother-in-law and two lodgers. Sam Harris's forge is by the other cart, and we are facing towards Portishead. These mature trees, since lost, lend the road a quite different, more bucolic aspect, than it has nowadays.

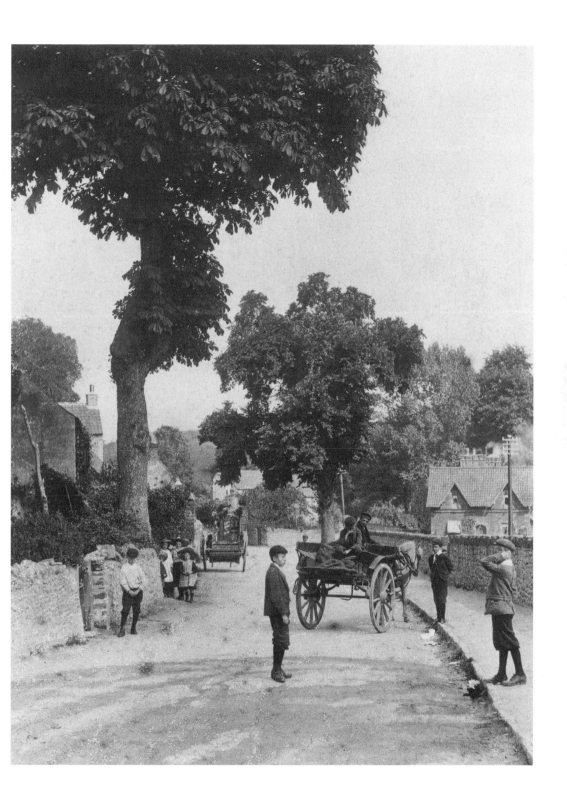

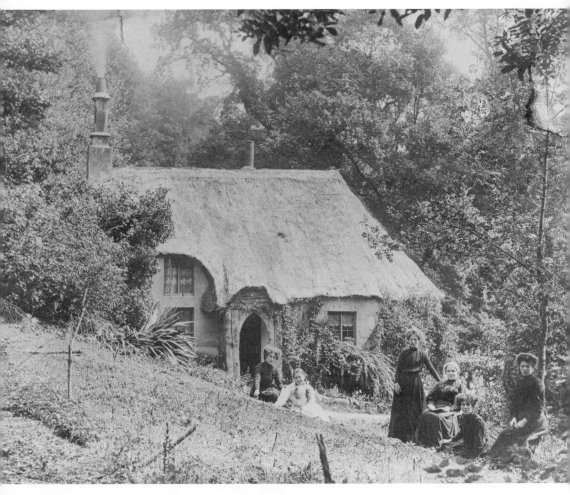

Here are members of the Evans family, who rented the cottage on the south edge of Court Woods, now overlooking the motorway, in 1911. On the left there is Miss Maude Evans with Muriel Mills. The older lady seated to the right is the matriarch, Mrs Thomas Evans, with three of her other daughters, Catherine, Agnes and Margaret. Thomas Evans had recently died and the family had come here from Lancashire to recover. He had been the international general manager for the Wallpaper Manufacturing Co. of Darwen, now Crown. The cottage had been occupied previously by the woodman William Lee, whose son George had bred the Clevedon violet. It was then called Wood Cottage, but has since been renamed Queen Anne Cottage.

Keeper's Cottage in Court Woods was designed for Sir Arthur Hallam Elton in the 1870s by John Birch. Sir Arthur had a keen conscience where his estate housing was concerned, and as well as building decent cottages, he instigated the survey of Clevedon's sanitation which led to the formation of a Local Board of Health in 1854.

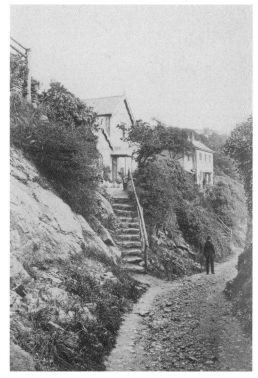

These cottages are on the Zigzag linking Hill Road to Dial Hill, built by Thomas Poole, who built eight dwellings on a plot he bought in the mid-1820s. In 1863, the Eltons purchased these buildings and laid out the Zigzag as a picturesque public path. The railing at the top left shows where there is now a seat, on the site of an old gazebo.

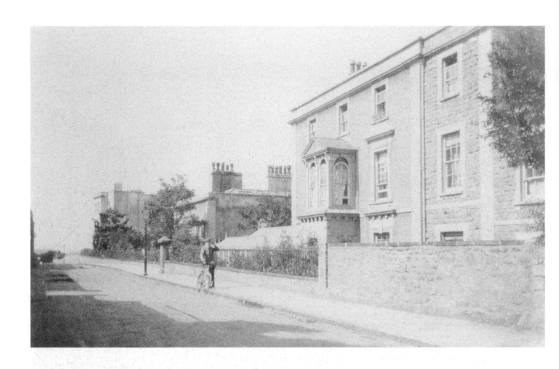

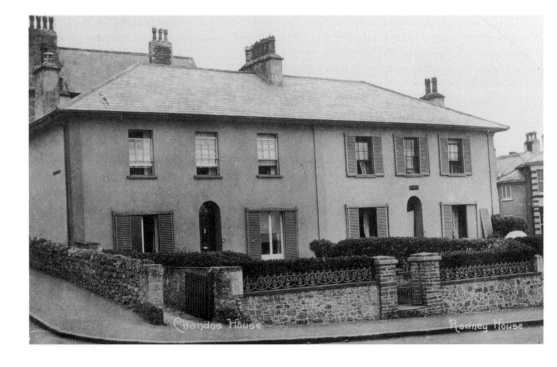

Chandos House Rodney House

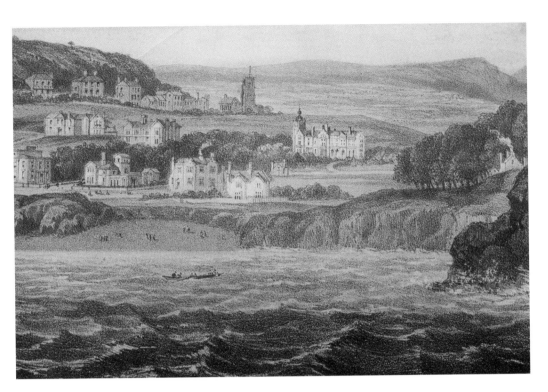

This view inland from the sea shows houses since demolished in Elton Road. From the left, the houses fronting the sea are Oaklands, then The Hawthorns, followed by Fairfield. The smaller, double-gabled house next to that is The Thatched House, which is now The Little Harp. The house with the dome is Clevedon Hall and the small cottage on the right is below Salt House. Behind Oaklands, Springfield and Whitehall can be seen.

Opposite above: In Wellington Terrace stood Cliffe House with its elaborate and distinctive porch. It was built by William Hollyman, and became a lodging house early on, later run as the Cliffe Hotel. This view of the terrace has changed enormously with the replacement of this and other fine Regency houses with large blocks of flats in the 1970s.

Opposite below: The Morgan family bought a large building plot in the late 1820s reaching from The Beach to Copse Road and built four houses on it. Chandos and Rodney House, shown here, are on The Beach and now used as a restaurant and offices respectively. In this photograph, the houses still have their sliding shutters, a rare architectural survival.

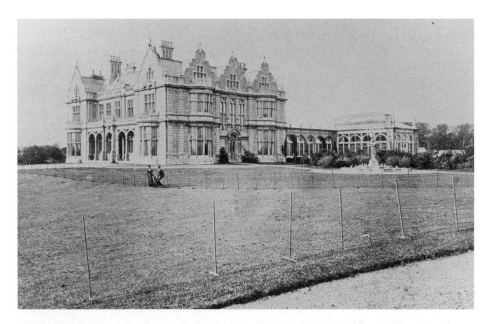

This house has gone through several name changes. Built in 1853 as Frankfurt Hall by Conrad Finzel, a philanthropic sugar merchant of German stock, it was renamed Clevedon Hall by the Hill shipbuilding family when they bought it. It became a boarding school after the Second World War when St Brandon's School moved to Clevedon from Bristol. This picture shows it in 1878 as a large private mansion in its own grounds.

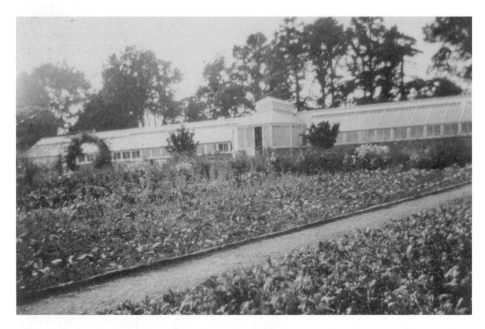

When Clevedon Hall was sold in 1900, the conservatory alone was described as 100ft long and on average 19ft wide, with a tessellated floor. There were also glasshouses measuring over 200ft in length tended by the gardening staff. The tropical house where the peaches and other tender fruits were grown was magnificent as you can see here and kept in immaculate order.

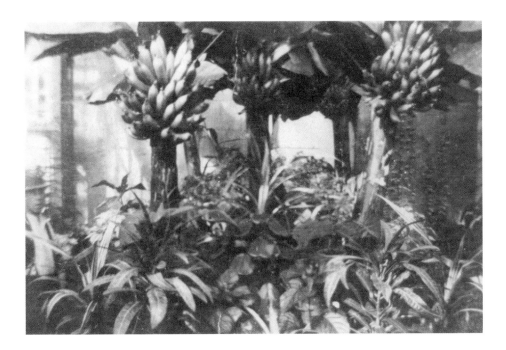

Above: The outstanding achievement in the tropical house was Bert Neads' Clevedon-grown bananas! Everyone has heard the old joke about the banana boats coming up the river to land their cargo at Kenn Pier – Clevedon Hall went one better and grew a crop at home. Large houses were almost self-sufficient in fruit and vegetables, even as late as 1925 when these pictures were taken.

Right: This is the man in charge of the tropical house, Herbert Edward Neads, 'Bert'. He was a member of a Clevedon gardening dynasty headed by the locally well-known Louis Neads of Sunnyside Nursery. He would have supervised the furnace which ensured the efficient growth of peaches and melons as well as other exotic fruits.

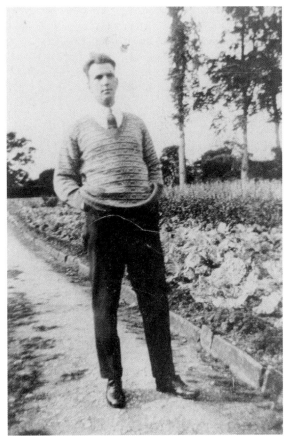

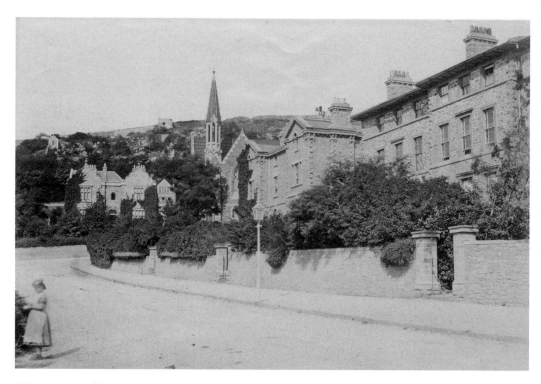

This is a wonderful insight into the beginnings of Bellevue Road. The house facing us towards the left is Burstead, named after Little Burstead in Essex where its first occupant was born. This was the Revd Ernest Fothergill, a curate of Clevedon. The buildings at the right of the picture are Bellevue Terrace, and Miss Sadler's Boarding House is between them and the Congregational church.

Opposite above: Backing onto Bellevue Road is Herbert Road, seen here pretty soon after the completion of the original terrace of houses begun in 1864. The imposing terrace has been carefully designed with the use of various stone and changes of level in the frontage. The gardener in the foreground seems to be tidying up ground belonging to Cotswold House in Linden Road, a private school until 1875.

Opposite below: Here is Linden Road seen from Prince's Road. It was an extension of Bellevue Road until 1864. Southview is on the left, and on the right, going away from the camera, Waterford House, Chester Lodge, Boddington and then with the dome, Rutland Lodge. In Boddington House there was a room fitted with an organ where recitals were given to raise money for local good causes.

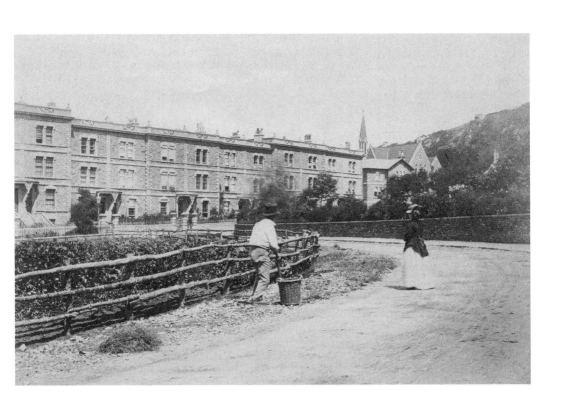

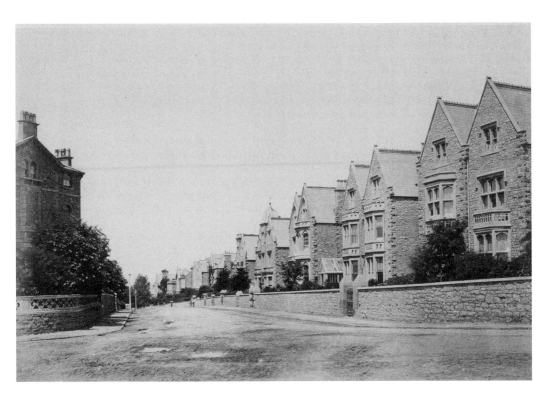

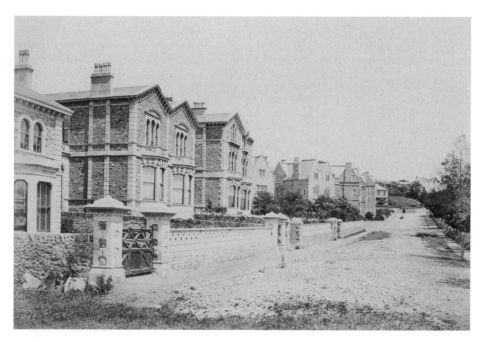

This is Prince's Road looking towards Hill Road, with the corner of Linden Road beyond. The roads were unmade, and the Board of Health contracted local firms to go around with a water wagon to lay the dust. One of the contract specifications was that 'a man, not a boy' should be in charge of this task – evidently there had been trouble with a young employee in the past!

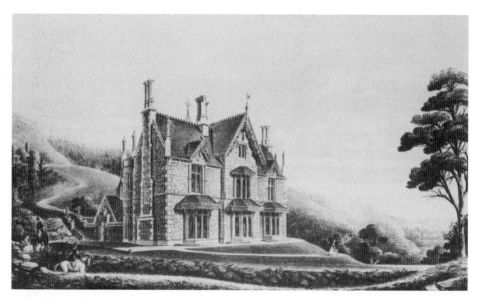

Mount Elton is the most exquisite house of its period in Clevedon, standing in Highdale Road in extensive gardens, with a rustic bridge to more gardens opposite. The house was designed in 1844 by Samuel Whitfield Daukes, in the Elizabethan style, for the Dowager Lady Elton. She planned the Regency landscaping of Court Woods and the Fir Woods, as well as making many fine sketches of the area.

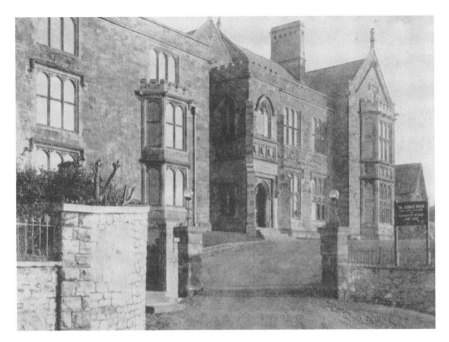

Highdale Road's Regency character is well-preserved. Land falling steeply away opposite the houses has prevented development on that side of the road. Claremont, shown here in the late 1930s, was greatly extended by the Braikenridge family. They bought the pair of Regency villas which show to the left of this picture and built the Gothic wing to the right during the 1860s.

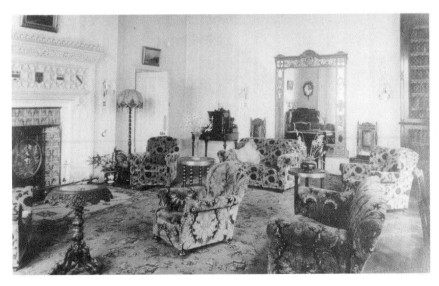

William Braikenridge, the first owner of the house, was an antiquarian and collector, who furnished the house with many valuable architectural features. These features almost all survive, heavily protected with preservation orders. This photograph of one of the sitting rooms was used to promote the house as a hotel between the wars, and shows one of the fireplaces designed for the house.

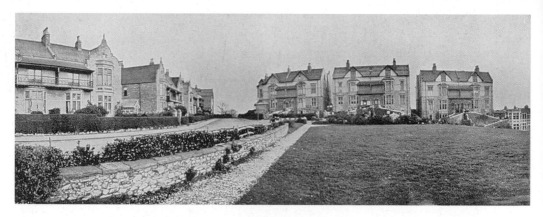

William Green was quite a pioneer in house building. The photograph dates from 1903, but he began building in 1894 on this site above Hangstone Quarry, gradually completing houses in many of the roads that now surround it – Jesmond Road, St John's Road and Avenue and Victoria Road. These vast edifices in Jesmond Road were the first houses in Clevedon to have indoor flushing lavatories upstairs. The lift from basement to ground floor mentioned here was the dumb waiter which saved kitchen staff carrying food upstairs. The modern age had arrived!

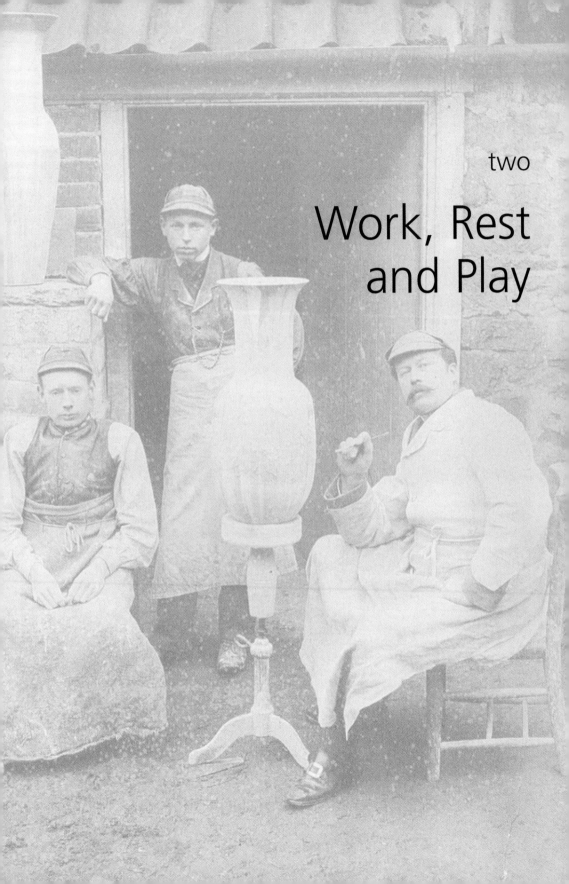

two

Work, Rest and Play

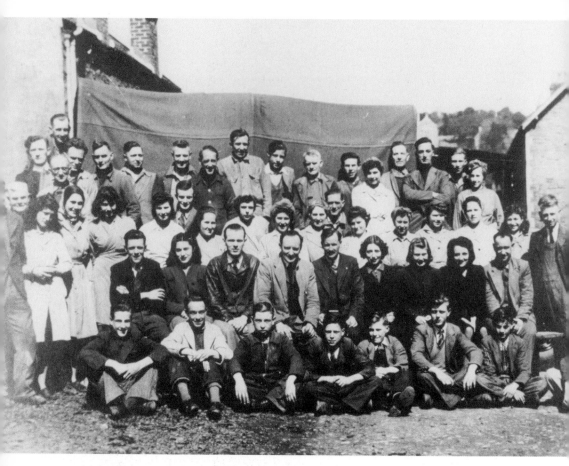

Tim Miller, the founder of Millcross Woodcrafts Ltd, moved to King's Road in Clevedon in 1932 and set up in business in 1933 in a small garden hut. I am told by Alan Blackmore that Mr Miller was known as the man who 'made a mint out of a hole'. Legend has it that he started his works making decorated stools for children with the circles of wood cut out of wooden lavatory seats. In 1937, the company's goods were reserved sight unseen by Selfridge's at their stand at the British Industries Exhibition at Olympia. By the time this picture of the staff was taken in 1947 the factory was at the back of No. 24 Griffin Road, where they made surrounds for barometers and hand-finished wood ware.

The names of those shown are: Ron Clarke, George Poulteney, Alan Thomas, Fred Dark, Cliff Marshall, Vic Rawlings, Jack Selwood, Trevor Cridland, Cyril Purnell, Ref Fortune, Jim Harrell, Ron Cook, Jim Fearnley, Jack Brooks, Winnie Brooks, Alf Brice, Jack Musto, Bern Read, Joan Rawlinson, Hedley Tucker, Donald Croft, Margaret Howards, Alma Shipway, Betty Craster, Vera Jones, Pat Till, Frances Wilson, Betty Drew, Lil Poulteney, Gertie Rawlings, Helen Stockham, June Sharp, Millie Merrit, Joan Youde, Alf Plumley, Ken Knowles, Hazel Cleverley, Marjorie Bailey, Daphne Bowen, Tim Miller, Alan Tuck, Florence Wainwright, Glyn Jones, Pete Till, Ted Youde, Fred Woodman, Philip Hill, Philip Binding, Graham Neath, Les Reed and Gordon Morris.

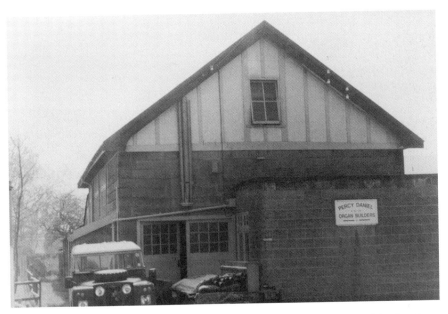

One of Clevedon's more unusual firms was Percy Daniel's Organ Works, based for decades in East Clevedon. The factory began in the old brick-built village hall across the Tickenham Road in about 1906, and moved to this site in 1930. The Mazda showrooms now occupy the site by Daniel Close. In the late 1990s the works moved to Beach Avenue, but have since closed down. Their work was known countrywide.

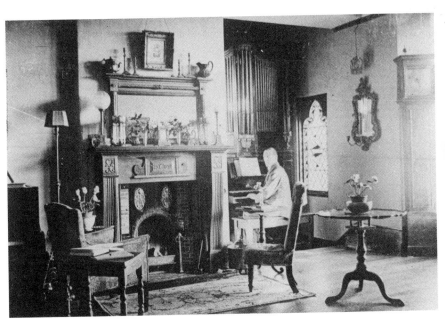

Mr Daniel lived in a house called Eckersley in Walton Road. Here he had a Gulielmus Bate chamber organ built into one of the reception rooms. In 1945 it was played on the radio by the organist of St Mary Redcliffe in Bristol, with an explanation of some of the instrument's features by Mr Daniel himself. The case was late Sheraton feathered mahogany, inlaid with ebony.

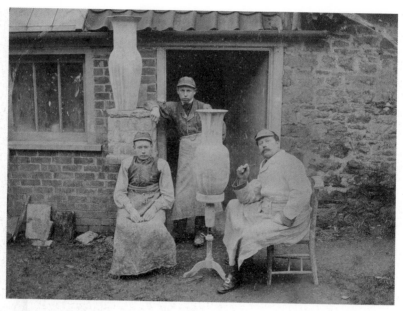

The staff of the Sunflower Pottery in 1888 at Clevedon Court, from left to right: George Masters, Charlie Neads and Sir Edmund Elton, widely known as 'The Potter Baronet'. George Masters made pots and Charlie Neads stoked the kilns. Sir Edmund developed some remarkable glazes and shapes in his forty years of work, now highly popular among collectors.

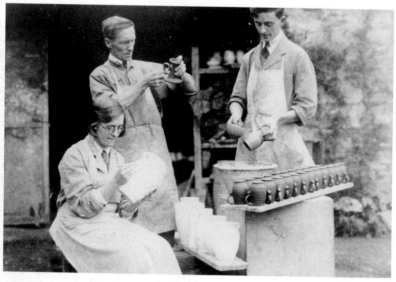

When Sir Edmund died in 1920, his son came to an arrangement with William Fishley Holland, centre, standing between his son George and daughter Isabel. Holland declined a partnership with Bernard Leach, and came from Braunton to Clevedon where he continued working with Devon clay. The Sunflower Pottery closed after a year and Holland moved operations to Court Lane. Holland Pottery passed out of the family in 1977.

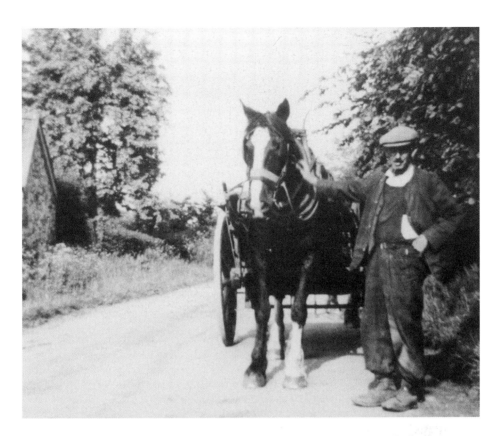

Above: Small concerns in Clevedon were often one-man shows, like the milk round run by Harold Hobbs from Norton's Wood Lane. Doreen Cooke, *née* Sulley, tells me that Harold was locally known as the 'Midnight Milkman', because he milked his cows in the small hours of the morning, then set out on his round!

Right: In the early seventeenth century, William Golde's farmhouse stood on the corner of Kenn Road and a lane now forming Shelley Avenue. By the 1800s, however, it had become a tied cottage for Tutton's farm in Moor Lane. In the late 1920s Bill Ford was a milkman there. He had a few cows in a field behind the cottage, and here he is shown returning from milking.

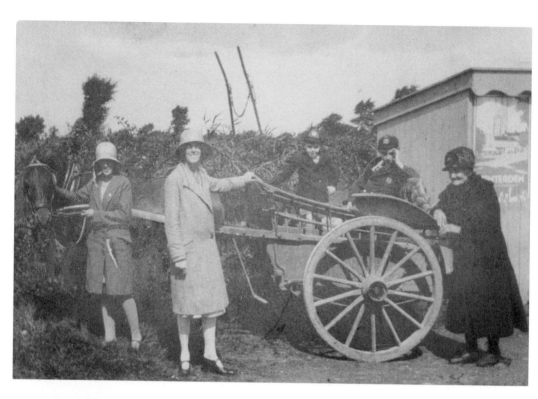

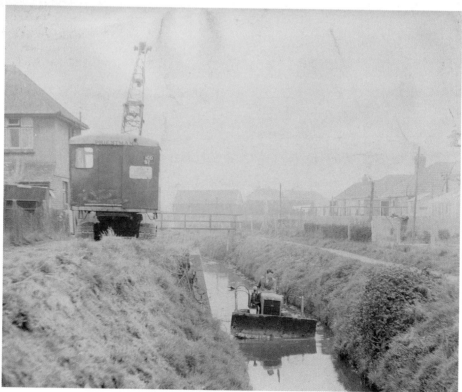

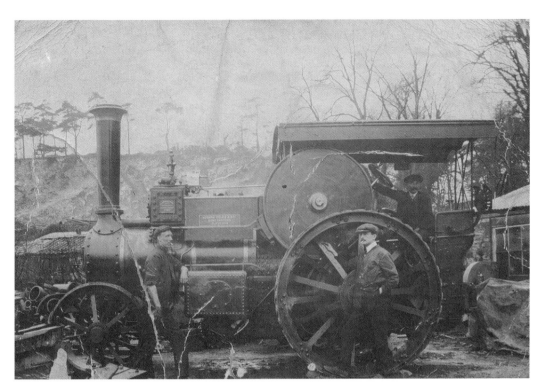

This handsome traction engine was used in the lower quarry in Holly Lane, on the left-hand side going away from the Walton Road. The proud owner in 1914 was Joseph Coles, whose son, George Edwin Coles, is standing by the rear wheel. George served with the 4th Gloucester Regiment during the First World War. Joseph worked hard to build up his business. He was a plasterer to begin with, then a builder, becoming a contractor and stone merchant, taking on general contract work after the First World War.

Opposite above: This was the scene at Kingston Road Halt on the Weston, Clevedon & Portishead Light Railway in August 1930. The halts on this railway consisted of small wooden sheds! Joan Griffin is holding Dolly the pony. Her son Bill is in the back of the trap, leaning towards his grandmother, Mrs Griffin senior. This halt is where their milk was collected and put on the flatbed truck nicknamed 'the flying bedstead'.

Opposite below: On the right are the backs of houses in Oldville Avenue, and on the left is Hillview Avenue as it was before rebuilding in recent years. Uncle Derek took this shot of the Middle Yeo being 'keeched', or scraped out, in the 1960s. The river is now piped beneath the Middle Yeo Path.

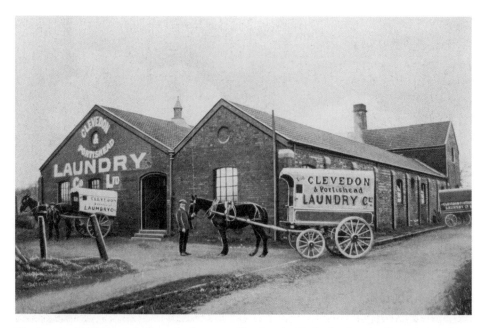

The laundry building was built to the latest specifications in Kimberley Road, off Strode Road in 1900, the firm being founded by Captain Mardon, RN. This picture was used in a leaflet published in 1911, in which potential customers were urged to arrange for a visit from the manager or manageress in order to have a full explanation of the processes and prices involved.

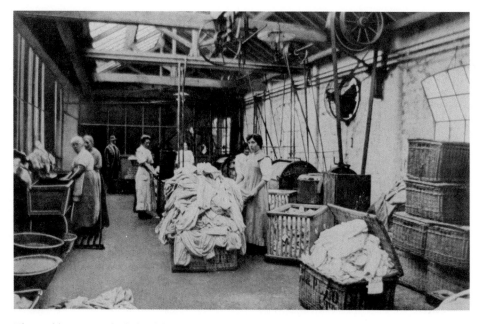

The washhouse was the hub of the enterprise, and the company took pride in the fact that their equipment was the most up to date, with the linen gently rolled and squeezed and only the purest soap and soda used.

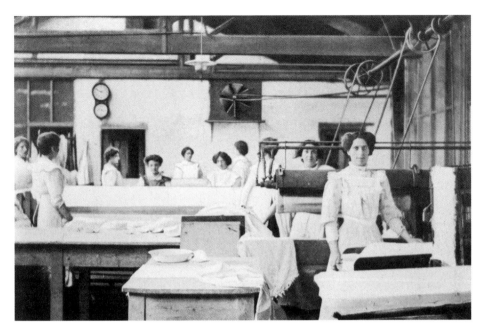

The machinery was steam driven from a boiler housed at one end of the complex. This powered a drive shaft and various belts were run from the shaft to turn both these collar-finishing rollers and the ironing machines. Several thousand collars were dealt with during a week's work.

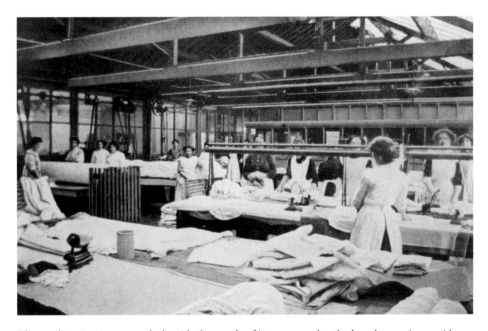

The machine ironing room dealt with thousands of items every day, the laundry serving a wide hinterland which ranged from Winscombe to Portishead and Bristol, and from Clevedon to Flax Bourton and Tyntesfield.

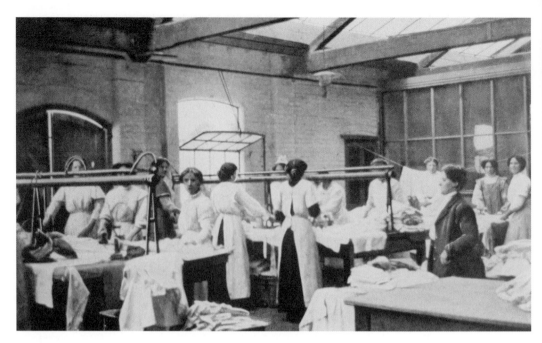

The lady in the hand ironing room wearing the jacket is probably the manageress herself, at this time Mrs Stuart, the wife of Henry Stuart, the manager. Between twenty-five and thirty staff were employed in this department, and only the very best work was accepted.

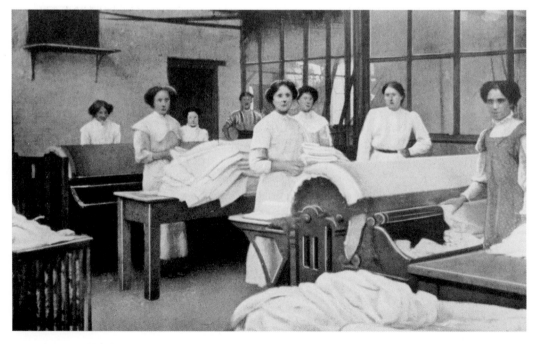

Large flat items, like sheets and table linen were put through these machines, with felt-covered rollers exerting only the minimum pressure needed to iron them, avoiding wear and tear from repeated use of heavy irons.

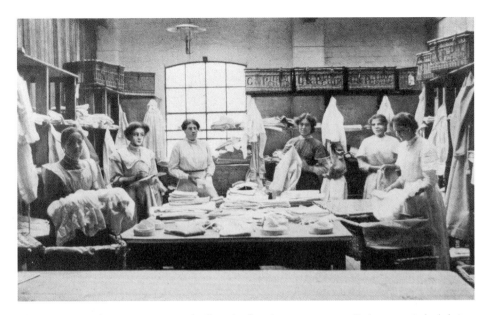

The next stage, of course, was to get the linen back to its proper owner. Each customer had their own rack, and by careful identification of discreet laundry marks, items were put together and packed for their journey home in one of the company's vans. The large wicker hampers do not seem to have survived, but I have a shirt box used by the laundry in later years.

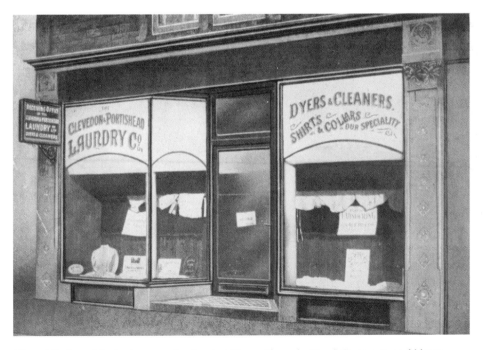

The public face of the business was the depot at No. 25 Alexandra Road. Customers could leave articles here for express collection, with special instructions for the treatment of the articles left, if necessary. A price list from 1964 gives detailed information on charges for laundering and dry cleaning.

The old copse called the Ripple used to fill the area between The Beach, Hill Road and Elton Road, giving Copse Road and Woodland Road their subsequent names. The remaining woods were used as quiet, contemplative spaces from the early 1800s. The keys could be obtained from Mr Gurney's grocery shop in Hill Road, opposite the upper gate of Alexandra Gardens.

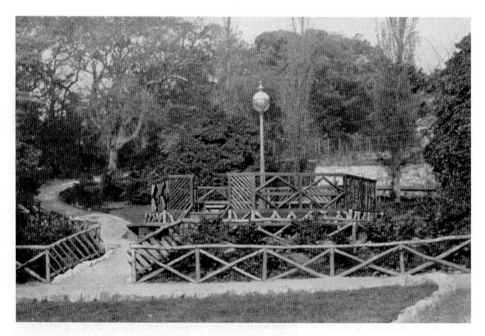

Bands visiting Clevedon during the season would have played here in the peaceful summer evenings – perhaps not so peaceful once they began to play, since the hill behind this bandstand in Alexandra Gardens would have provided very good acoustics! The Pier Copse and these gardens were laid out in the 1820s by the Elton family, who eventually gave them to the town.

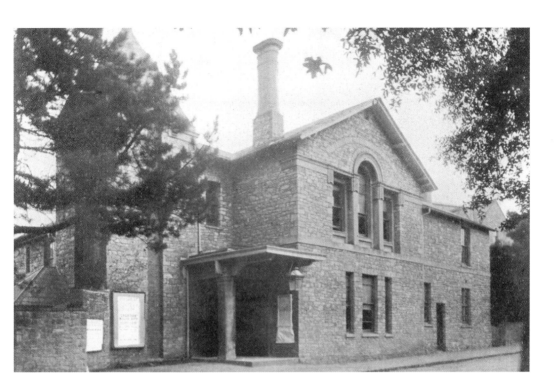

Above: The Public Hall now houses the *Clevedon Mercury* offices (beneath the pediment), and in the section of the building to the right is the Masonic Hall. The hall was the brainchild of Sir Arthur Hallam Elton, and here as many as 300 people could be entertained for public dinners or for concerts. In 1902, some of the earliest moving pictures were shown here to promote Mr Britten's new shop by the Pier.

Right: This is the photograph from an illustrated advertisement in the *Clevedon Mercury* calendar for 1913. The owner and builder of the Picture House was Victor Cox, a young man of imagination with a keen sense of publicity. The Picture House was built in this form in 1911-12 and opened in April 1912. Rebuilt in the 1920s as the larger cinema we now know, it has been running ever since!

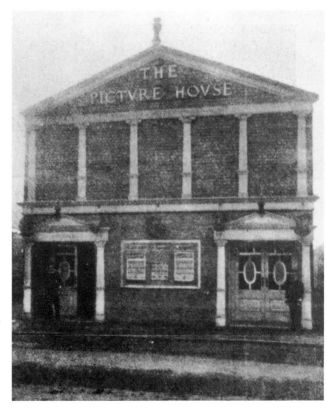

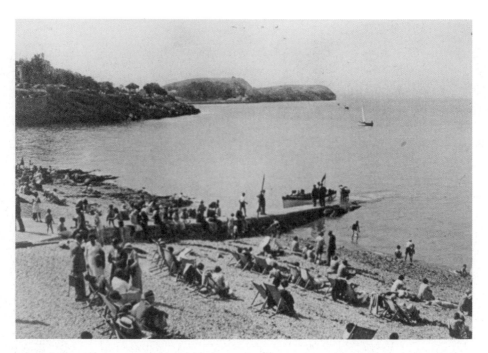

In the 1950s, you could have the traditional trip round Clevedon bay with the local boatmen, just as you could have done 100 years before. One of these boatmen was Derek Bird, who bought the *Y-Not II* from Mr Rich in 1954 and gave trips to the lightship and Flat Holm in her for five years. In 1959 he bought the *Nancy Lee*, used until she was lost in a gale in 1974.

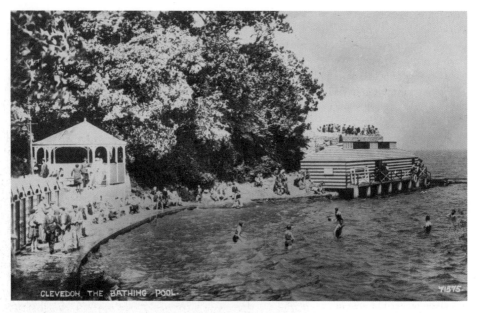

In its heyday before the Second World War (opened in 1929) the lake was very popular. As well as changing huts, glimpsed to the left, there was a pavilion for swimming club members to the right, and a bandstand into the bargain. Rita Gregory tells me that accordion bands played here, providing a 'seasidey' atmosphere. In time, the bandstand was converted to provide a ticket office and locker space.

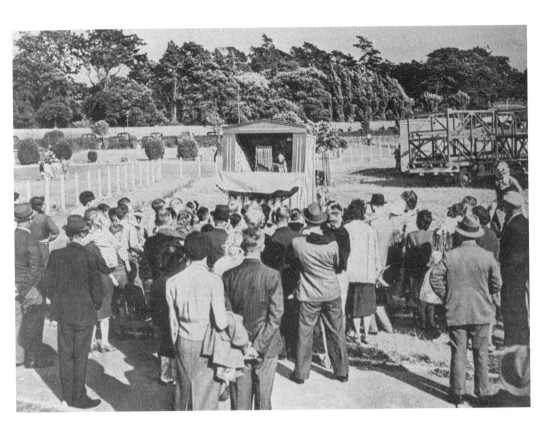

Above: This is from a guide book of the early 1950s, showing the Green Beach with an audience captivated by the age-old tricks of Mr Punch. The average age of the crowd is surprisingly high – perhaps all the children are at the front.

Right: Fairs, circuses and shows have been held in several different venues in the town, among them fields off Teignmouth Road, Kenn Road and Beaconsfield Road. These have since been developed for housing. Salthouse Field, shown here, is the last of the venues still in use. This photograph was taken by Mr E. Caple in the early 1950s and the place is hopping!

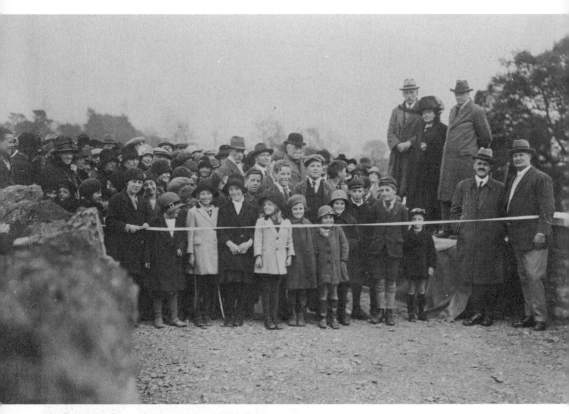

At the back of Salt House, the woods were laid out with paths and opened to the public by
Cllr Mrs Donaldson, during Easter 1928. Here, standing above the crowd are Mr Edmund Shopland,
Mrs Donaldson and Sir Ambrose Elton, and below them to the right, Mr Nutting and Mr William Hill.
Cllr Nutting had promoted the development of the Marine Lake, Mr Hill was the contractor. Using an
employment scheme which gave much-needed work, the footpath was improved by extension to Wain's
Hill the following year, forming what is still the popular Poets' Walk.

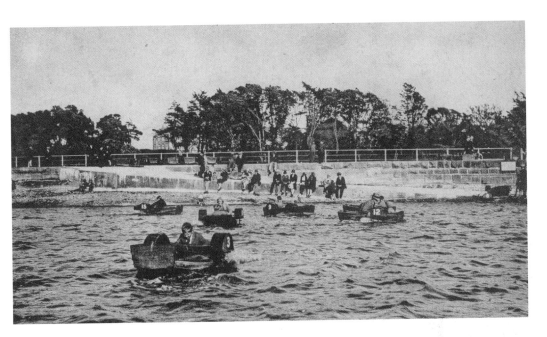

Above: The tide-filled Marine Lake was an exceptionally good idea for a town on the shores of the Bristol Channel, where the difference between high and low tides is 47ft at its extreme. This is second only to the tidal range of the Bay of Fundy in Canada. The lake provided excellent safe boating facilities for children, as well as swimming when the tide was out.

Right: Right at the small-scale end of catering and refreshments was the ice-cream man. This is Alfred Oakley, who lived at No. 93 Old Church Road. I can just remember the ice-cream tricycles in the later 1950s, and I suppose that soon afterwards they were superseded by ice-cream vans. Mrs Oakley is to the left, holding their niece, Doreen Sulley.

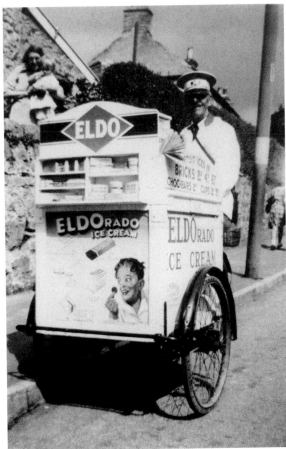

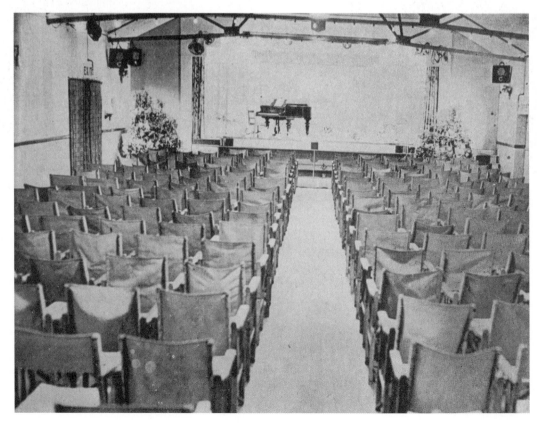

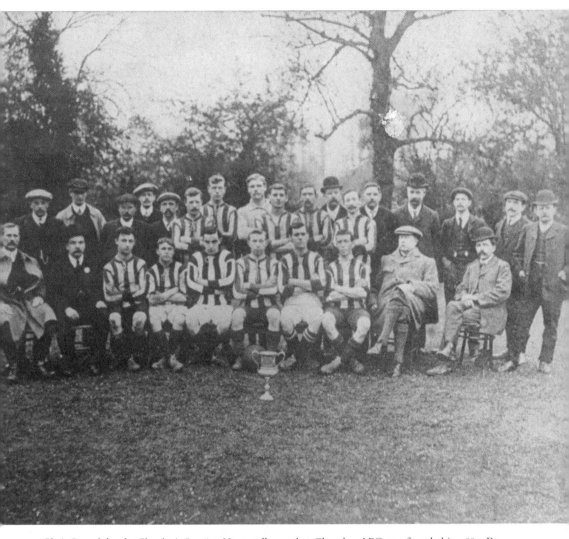

Chris Stone's book, *Clevedon's Sporting Heroes* tells me that Clevedon AFC was founded in 1880. By 1910 they'd had twenty-nine years' experience at the ground on Dial Hill. They later moved to the Teignmouth Road ground, and in 1990 that pitch was sold for housing. The club relocated to the Hand stadium, named after the family long involved with the club – H.G. Hand is in the front row.

Opposite above: Reginald Perkins, an excellent local photographer and a Fellow of the Royal Photographic Society took this photograph. It was published in the *Clevedon Mercury* to show the new lecture hall attached to the Baptist church in Station Road. Thanks to a kind donation, this hall was completed in 1937 for £3,000 – 200 people could be seated.

Opposite below: Here is an invaluable picture from a local guide book of the 1950s, showing the interior of the Salt House Pavilion. The Keesey family, who set up the Salt House Hotel in 1927/28 were very keen to expand into entertainments, and held concerts and dances here on a regular basis.

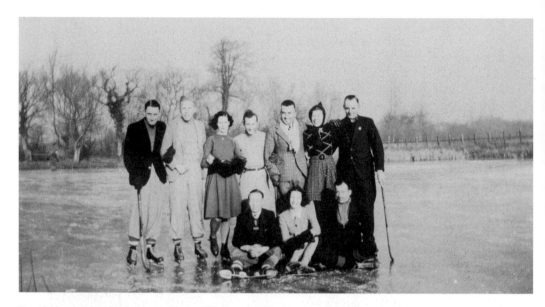

David Long's parents were keen skaters – Peggy Long had lived in Winnipeg in Canada – and here on Lake Farm pond in the 1940s they had plenty of congenial company. Peggy and Hedley Long are third and fourth from the left. The pond is off Cole House Lane.

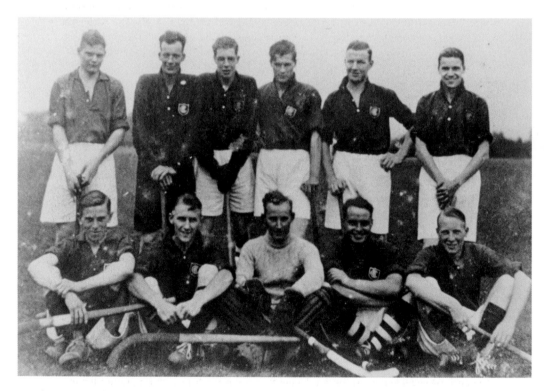

David Long, one of the most generous of local collectors, loaned me this one to copy. It is Clevedon Hockey Team in 1937. Back row, left to right: Tom Rogers, Ron Taylor, Stan Bennett, Ned Morrish, Frank Maynard, Sid Morrish. Front row: Ackland Cornish, Donald Long, Hedley Long, Herbert Reed, Bert Tanner.

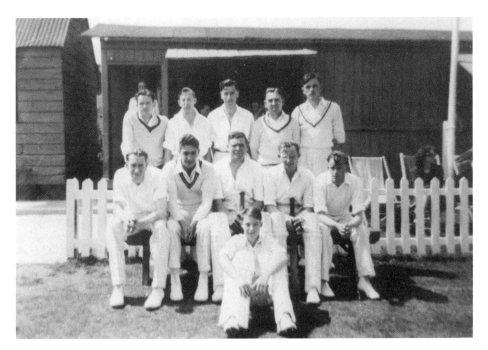

Clevedon Cricket Club's Second Eleven made a smart show in 1948. Peter Ganniclifft remembers his team mates as follows. Back row, left to right: Alan Bishop, Ray Binding, Norman Ashley, Harry Billing, Peter Ganniclifft. Second row: Mick Barrett, Dennis Bullimore, Bob Ricardo (a local policeman), Ron Matthews, Pete Jones. Last but not least Graham Tripp is sitting at the front.

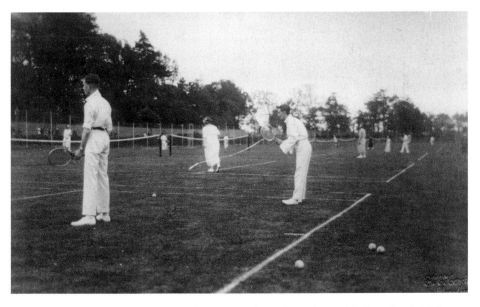

The council-owned tennis courts on Salt House Park are shown here, with Reg Ganniclifft in the centre playing in the first game of doubles on the court. In the 1923 Clevedon Directory, the prices for hiring the courts were a guinea for a season ticket, or 7s 6d for weekly tickets. Charges per hour were 6d per person, or 9d for two people.

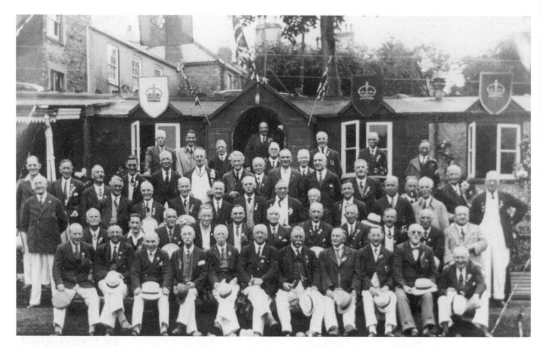

Clevedon Bowling Club celebrated their Silver Jubilee in 1936, a little late, since they were founded in 1910! However, the jubilee was a success, judging by the smiles. David Bryant, their brightest luminary, kindly looked at this for me and remembered these. Front row, left to right: A.S. Kent, -?-, C. Purnell, -?-, -?-, -?-, -?-, T. Newton, -?-, -?-, T. Dawes. Second row: -?-, F. Hapway, A. Lane, -?-, -?-, W.C. Bryant, C. Mackerell, C. Blackwell, the rest unknown. Third row: unknown apart from J. Bennett on the right. Fourth row: T. Cole, W. Dyer, G. Siblett, R.H.S. Bryant, -?-, E. Webber, -?-, -?-, H. Youde, the rest unknown. And finally the back row, unknown excepting B. Parsons on the right. What a memory for names, even allowing for his father and grandfather!

Opposite above: Here are some familiar faces at an event at the Rifle Club's range at West End in Old Church Road in the 1960s. Cllr Tony Barker is firing the pistol, and left to right are Mike Hedger, Tom Hussey, -?-, -?-, Derek Lilly and Mervyn Potter. The club went into pistol shooting at this time, and soon competed nationally against the likes of the Special Branch. They were rated sixth in the entire country.

Opposite below: The Guiding movement really took off in Clevedon and here we have the 5th Clevedon Company in the mid-1930s. Back row, left to right: Ella Saunders, Isabel Crane, Olive Saunders, Doris Saunders, Pat Deacon. Third row: Joan Wallis, Betty Griffin, Sadie Penny, Kathleen Parker. Second row: Natalie Hawkins, Kathleen Harris, J. Davis, F. Bird, J. Martin, Molly Dugdale. Front row: E Hawkins, -?-, Colburn, Joan Feltham, J. Phillips, D. Pumphrey, -?-.

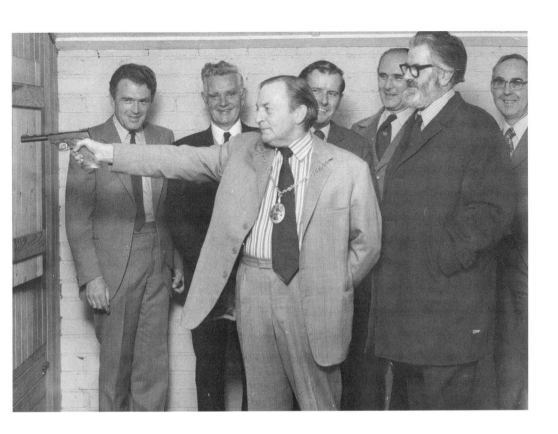

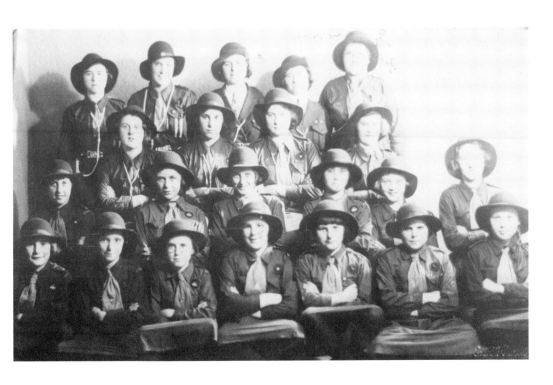

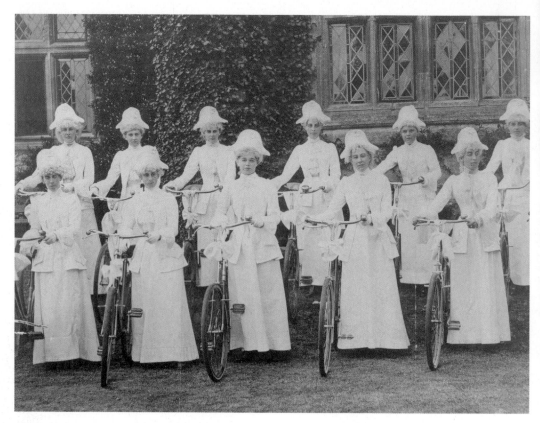

These ladies rode to music in 1901 for charity! Clevedon Court's lawns were so dry on this occasion that they had to be watered, to prevent undignified slithering. Left to right: ? Hay, ? Evans, Violet Lucas, Lilian Lucas, Molly Baker, Evelyn Beloe. Front row, left to right: J. Jones, Stafford Jones, Phyllis Beloe, Hilda Dobson and Kathleen Parr. The ride was repeated with electric bicycle lamps in the dark at a fête at Clifton Zoo.

three

Enjoy your Stay

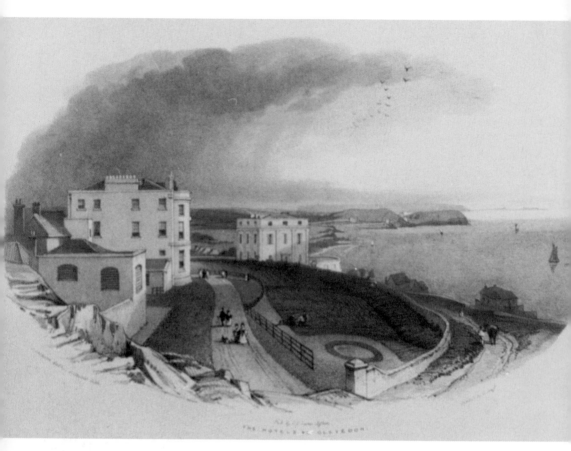

This engraving demonstrates the splendid isolation of Clevedon's first two hotels. In the foreground is Hollyman and Newton's Royal Hotel, built in 1824/25 on the site now occupied by the Friary church with its hall and living quarters. Beyond is the square is York Hotel built in 1833/34 by George Fowler, its coffee room just a step below. Both had magnificent sea views and were in healthy competition with each other. Their advertisements reflect the comfort offered to the visitor: horse-drawn taxis met the trains, the London newspapers arrived promptly and fine wines were available.

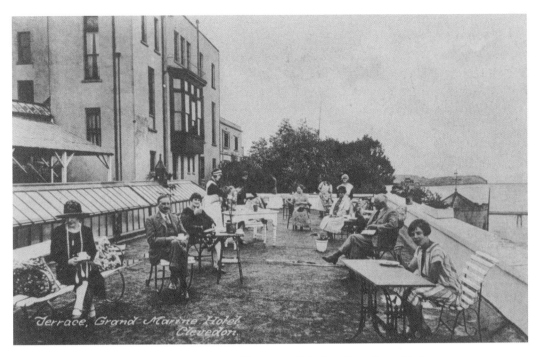

The Grand Marine Hotel was on the site of the present Edgarley Court flats, with this spacious terrace overlooking the sea. The house had been built in about 1828 as Wellington House by William Hollyman, and was the first house in Wellington Terrace.

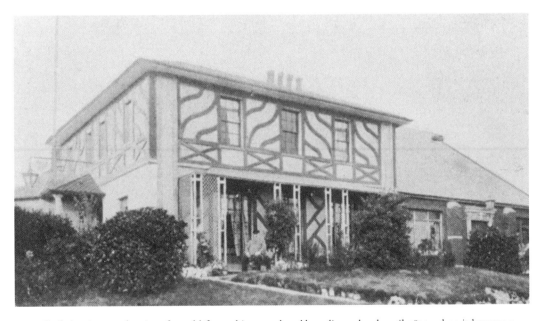

Built in 1823 on the site of an old farm, this was a boys' boarding school until 1835, when it became a hotel. For thirty years it was run by John Pearce. When the railway arrived in 1847, the pub's success was assured, and was for many years promoted as 'The Home for Commercials'. By 1910, the Bristol Hotel's lock-up coach houses were used to provide garaging for customers' motor cars.

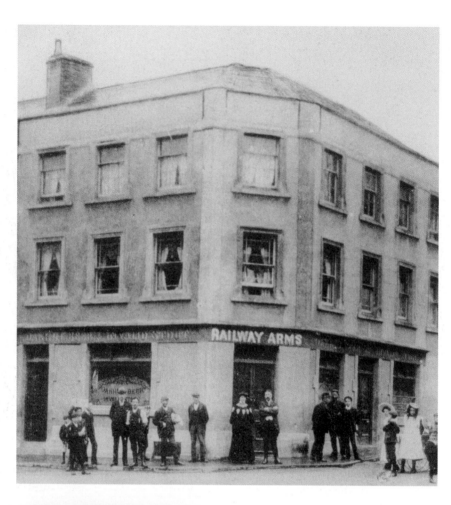

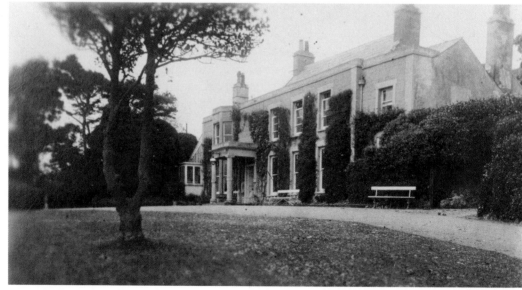

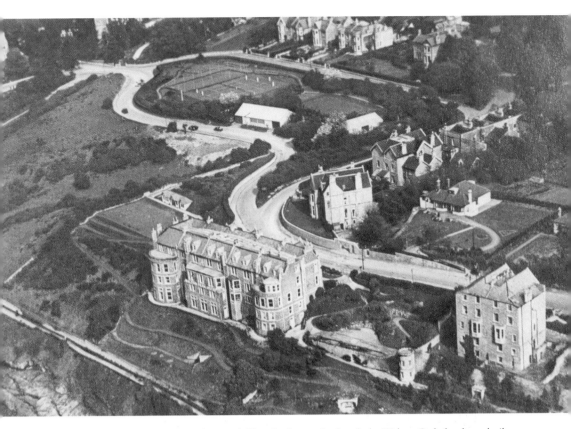

A fair amount of the open ground around Clevedon's premier hotel, the Walton Park, has been built on since this photograph was taken some forty years ago! However, here you can see the impressive terraced garden descending to the cliff path. In 1903, about ten years after it was built, the hotel was set in 7 acres of ground with summerhouses and gazebos for the 100 guests who could be accommodated there.

Opposite above: The Railway Arms has also been called Lloyd's, and is now the Clock Tower – but locals know it as the Corner. It is one of only three purpose-built pubs in Clevedon, the others being the Waggon & Horses and the Crab Apple. It dates from the late 1840s and the first landlord was Charles Salmon. When the photograph was taken, his grandson Thomas Salmon Ralls was the proprietor – part of a dynasty!

Opposite below: In its present form Salt House dates from the 1830s, when Ferdinand Beeston, a timber merchant, improved smaller dwellings here. It was a private house until the late 1920s, when the house and land was sold. The imaginative Keesey family ran the house as a hotel and turned the gardener's cottage into Salthouse Pavilion, used for dances and plays until the 1960s.

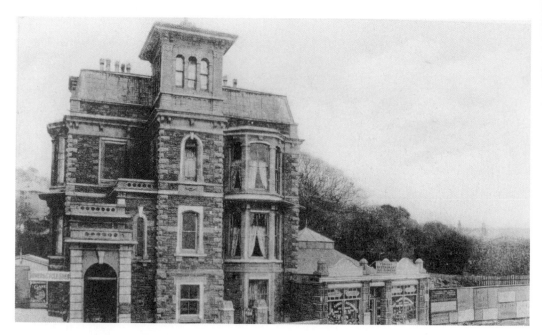

Here is The Towers, now Campbell's Landing, whose new name refers to the steamer fleet calling at the Pier. The place was put up as a dwelling house in 1863, six years before the Pier opened. It was of course an ideal site for entertaining Clevedon's visitors. Beginning as a lodging house, it became a restaurant seating 250 people and is now a pub where food is still popular.

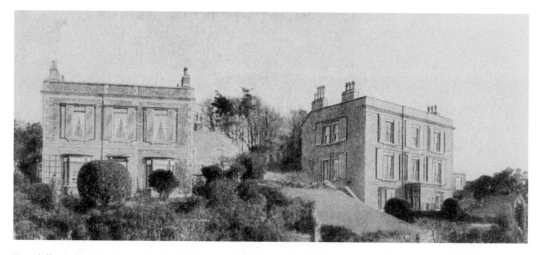

Stancliff, on the right, has only recently been sold by descendants of the Cottle family who built it. It was built as a boarding establishment at a time when the town's rapid growth meant a boom for those letting rooms. Stancliffe provided a 'liberal table, only the best of English fare – well cooked.' Carriage access was from the rear.

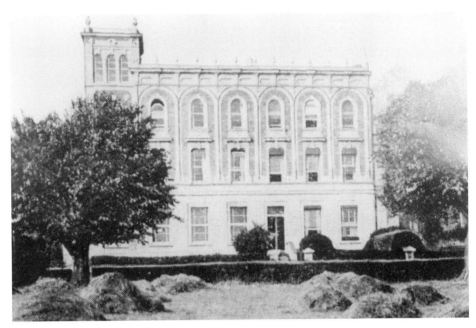

In this pre-war photograph from an old guide book, there are open fields opposite Charleville. Henry Howard built this vast place in the mid-1860s on the corner of Victoria Road and Albert Road. Between the wars it was a select boarding house, offering luxurious quarters with gas fires in bedrooms and hot and cold baths. All from 3 guineas a week!

I have always wondered why this house was built at an angle to the others on The Beach, and Alan Blackmore recently explained to me that it was in order not to obstruct the view of the sea from Grove Cottage or Grove Villa in Alexandra Road. Run at first as a private boarding school, and later as a guest house, Esplanade Villa is now the Moon & Sixpence public house.

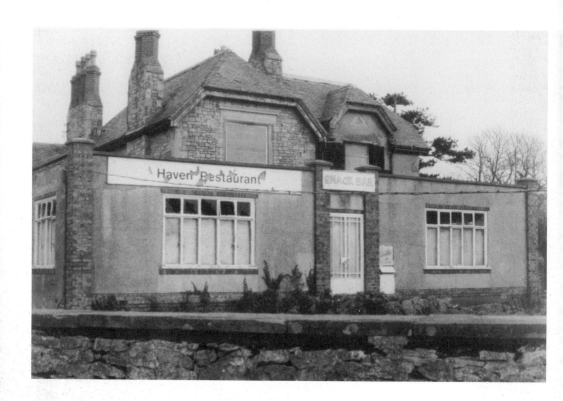

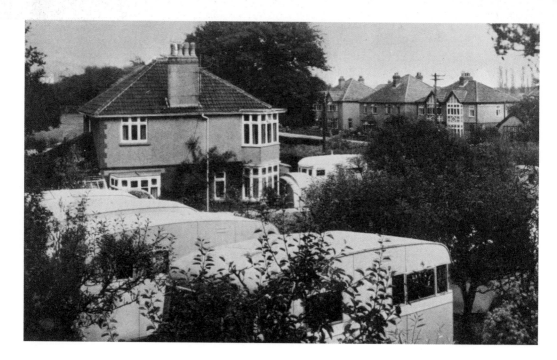

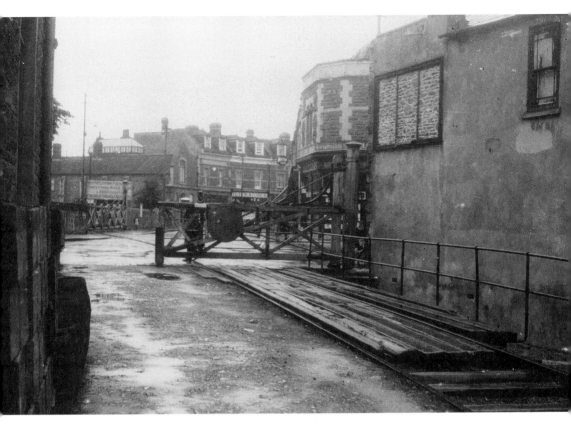

Here in September 1930 is part of the track bed of the local alternative to the GWR, the Weston, Clevedon & Portishead Light Railway, a line of legend! To the left is the wall of the Conservative Club, and on the right, Clevedon Engineering's premises. The old Baptist church with its skylight is seen across in Station Road. The level crossing gates were operated from a hut near the church. When the line was taken up in 1941 after bankruptcy proceedings, a wreath was hung in the Conservative Club in memory of a 'dear friend'.

Opposite above: The Thatched House was built as a dwelling around 1853, with lovely mock-Jacobean plastered ceilings, now concealed. As The Haven it was run as a cafe after the last war, becoming a grill room and restaurant open all year round, seating 150 diners outdoors and 100 indoors. It is now the Little Harp public house.

Opposite below: Taken from the edge of Old Church Hill this shows the site now occupied by the flats and apartments called Poets' Court. The caravans were rented complete with mains water, lighting and sanitation, from the West End Gift Shop just behind them. The gift shop later became a cafe, where autumn teas were served beside a real fire in the bay-windowed room to the rear. Old Church Road is on the right.

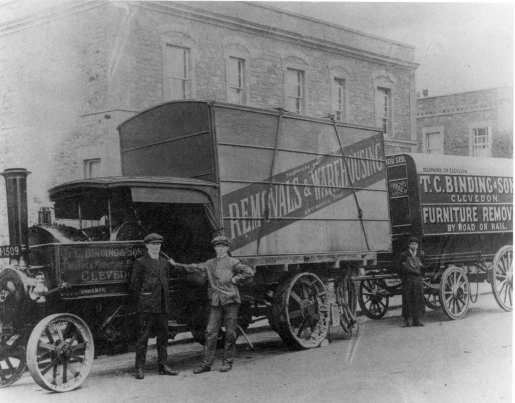

Opposite above: Even baskets of pigeons travelled from the Great Western Railway Station in Kenn Road! Some of the old pigeon lofts surviving in Clevedon's back gardens are still used. The pigeons were unloaded at a designated station down the line and released at a set time and clocked in by their owners as they came home. The Hovis sign across the road is above Parker's bakery shop.

Opposite below: As you can see just above the front wheel, this engine could do 5mph. Thomas C. Binding's was one of the early businesses in the removals field in Clevedon based in Kenn Road. His father was a haulier in Clevedon in 1881, and Thomas took over from him. The firm undertook furniture removals as early as 1914 and still advertised in *Kelly's Directory* in 1939.

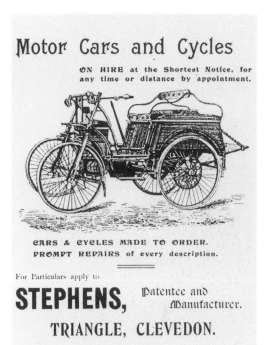

Motor Cars and Cycles

ON HIRE at the Shortest Notice, for any time or distance by appointment.

CARS & CYCLES MADE TO ORDER. PROMPT REPAIRS of every description.

For Particulars apply to

STEPHENS, Patentee and Manufacturer.

TRIANGLE, CLEVEDON.

Above: Richard Stephens was a highly talented motor car designer/builder and could have gone far if he had self-advertised. Here is his 'dogcart' of 1898, the first all-British car. It is now housed at Leonardslee Gardens in Sussex, and can run at 50mph with little effort. Clevedonians saw it when it was driven through the town in 2006. Stephens' premises were in The Triangle across the river from the Constitutional Club.

Right: Mr Evelyn Vernon seems to have been quite the pioneer! This advertisement comes from the *Homeland Handy Guide of 1910*, and in the *Clevedon Mercury* of 1911, Mr Vernon is listed as having 'The Garage' in Elton Road, with access between Clevedon College and Hallam House.

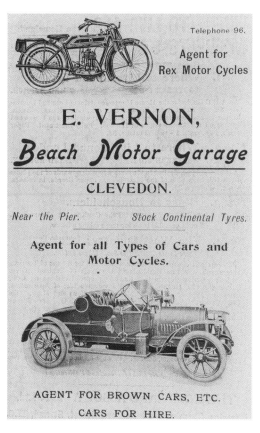

Telephone 96.

Agent for Rex Motor Cycles

E. VERNON, *Beach Motor Garage*

CLEVEDON.

Near the Pier. *Stock Continental Tyres.*

Agent for all Types of Cars and Motor Cycles.

AGENT FOR BROWN CARS, ETC.

CARS FOR HIRE.

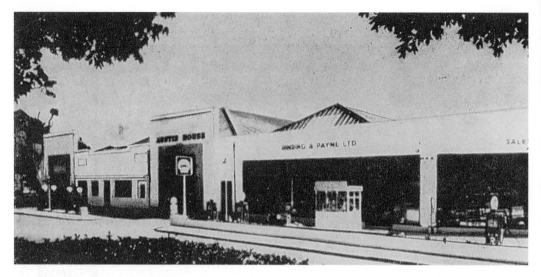

A.O. Binding and H. Payne opened the Central Garage in Old Church Road in 1919. In 1935 they rebuilt it in this bold Art Deco style only for it to be burned down immediately following completion. It was re-erected without delay to the same design, as seen in this photograph. The site was cleared in 2006 to allow for redevelopment.

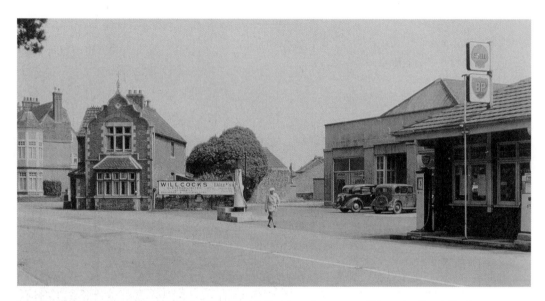

Morrison's Garage is now on this site in Old Church Road on the corner of Knowles Road. By the sign is the weighbridge house, built in 1869 to a design by the architect Hans Price. The weighbridge mechanism was sited in the road fronting the gable shown here. 'Jack' Willcocks, a gifted engineer was based at the garage. He worked on motorboat speed trials with Sir Henry Seagrave in 1930.

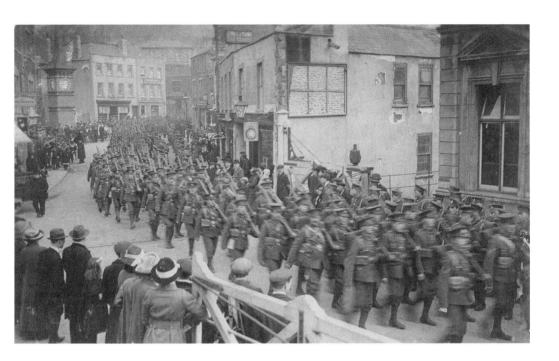

Above: During the First World War, soldiers were billeted all over Clevedon and there were many sad farewells when it was time for them to leave the town to go to Europe. Rob Campbell, local military historian, identifies these men as part of the Warwickshire Regiment. They are marching past the level crossing gates of the Light Railway in order to entrain at the Great Western Railway Station only a few yards further down Kenn Road.

Left: Before they left Clevedon, the bandsmen of the various regiments played popular music in the Green Beach bandstand. Here in 1915 the 7th Battalion Loyal North Lancashire Regiment entertains the genteel throng. The bright colours of the small gas lamps on the bandstand would have been a pretty sight of an evening. What a cruel contrast this must have made when the soldiers reached the trenches and remembered the calm of Clevedon's promenade.

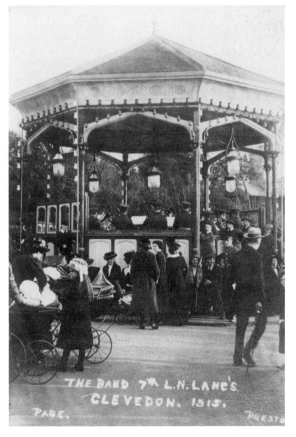

Above: Victoria Road with its drinking fountain shows how rural Clevedon still was between the wars. The fountain was re-erected here in 1904, having been in storage since its removal from The Triangle following the building of the clock in 1898. West Way now occupies the field to the left behind the milk cart, and the post box just beyond the fountain has gone, along with a few of the trees.

Below: The Sixways Clock lasted from 1903 until 1941, when it became Wartime salvage:

> Farewell! Farewell, dear clock, thou hast tried to do thy duty,
> But those in State decree thou art no thing of beauty;
> … But be thou not dismayed, thy time has not been run,
> Who knows, thou might be made into a Tommy gun.

Thus wrote a local poet in the *Clevedon Mercury.*

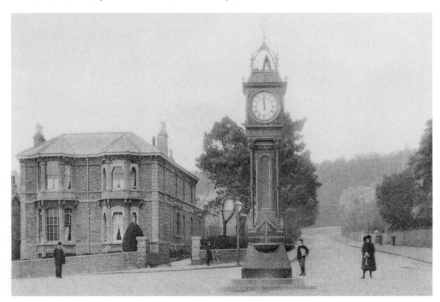

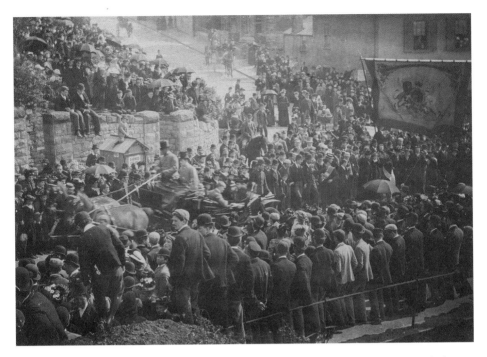

Above: This Pier reopened in April 1893, after the Local Board of Health, as new owners, had entirely reconstructed the landing stage at a better angle to the tidal race. Visitor numbes had declined after the opening of the Severn Railway Tunnel in 1886, but after these improvements the steamer trade picked up again. The military gentleman leaning on the carriage is Sir Edmund Elton whose mother performed the ceremony.

Below: In 1894, the addition of the elegant, iron-framed buildings at the end of the Pier further improved the facilities for passengers and visitors. After careful restoration in the 1980s, the buildings are now again available for visitors to the Pier to enjoy shelter from the Bristol Channel breezes.

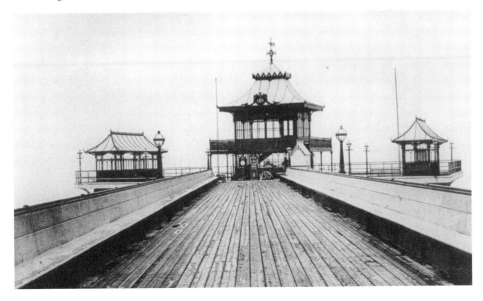

On the left of Jubilee Cottages in Old Street is George Bees, a respected local councillor. These cottages were opened in 1887 to house four deserving elderly folk at a low rent, but were demolished in 1993 to make way for the new car park at the Cottage Hospital. The ladies celebrating the Silver Jubilee in 1977 are, left to right: Lucy West, Mrs Olive Bray, Miss Dunster and Mrs Thoburn.

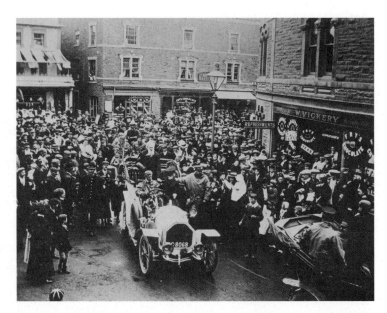

The venerable gentleman in the car is General Booth, Founder of the Salvation Army, a body which established an outpost here in 1901. The Salvation Army Hall in Old Street was built in 1904, and in August 1906 a tour was planned for the general, to include Clevedon, Yatton and Weston-super-Mare. This visit and the cavalcade of cars brought many of Clevedon's populace into The Triangle.

four

At your Service

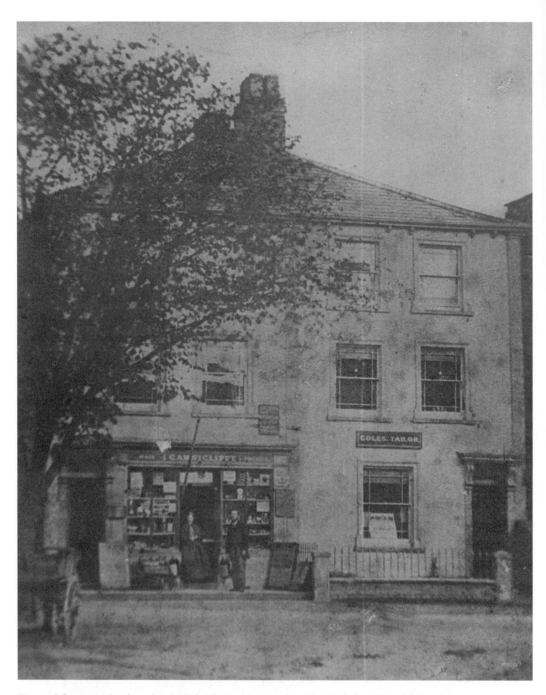

First and foremost, the shop that I think of when I remember The Triangle of my childhood, is Gannicliffe's, established in 1855 by the far-thinking William Pinkham Gannicliffe, from Exeter. The shop flourished until the 1970s, and was then the oldest business run by its founding family in the town. This is one of Clevedon's earliest photographs, showing the trees in The Triangle since cut down to make way for the drinking fountain placed there in 1867.

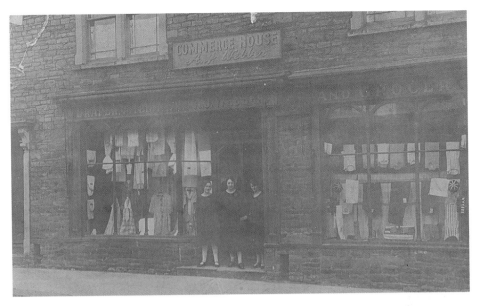

These ladies ran part of Webber's at Commerce House, now Humbert's Estate Agents, in about 1932. On the left is Mrs Warburton with Mrs Webber in the middle – the other lady is unknown. They sold drapery and millinery, while the window to the right showed Mr A.J. Webber's range of gentlemen's outfitting. The third shop of Webber's empire provided high-class groceries and was to the right of these two shops.

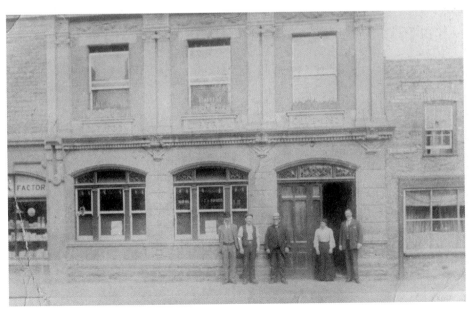

This may well have been taken soon after the opening of the Liberal Workingmen's Club in 1892. Now the Triangle Club, it has for some years been affectionately and unofficially nicknamed the Welsh Embassy! The shop to the right was demolished and replaced around 1920 by Robinson's Cafe, later the Gas Co. premises and shop.

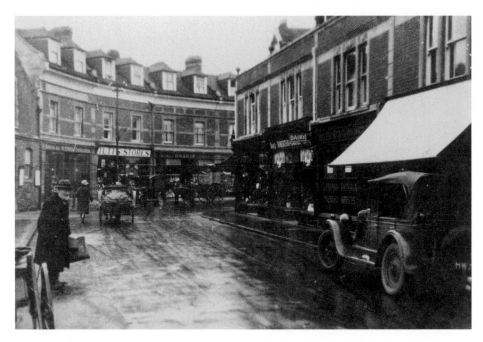

This early 1930s picture of Station Road shows, left to right, part of the Baptist church, Eyres baker's shop, Tutt's grocery stores, and Hasnip's butcher's shop. Beyond Hasnip's round the corner was the Rozmarie Cafe. In the row of shops on the right was Robertson's Dairy. On the extreme left is one side of a crank-axle milk cart – we forget how relatively recently horses were used for deliveries!

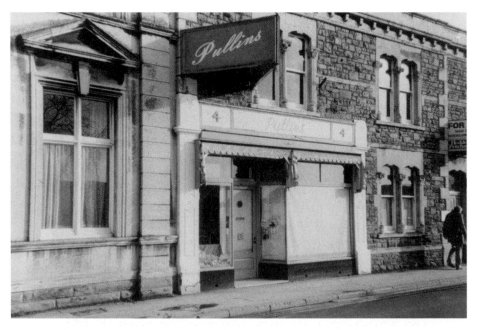

Pullin's shop was completely altered and extended in the 1980s, and now there are several extra shops in this row in Kenn Road, including a solicitor's office and an estate agent, as well as a photocopy shop and a hairdresser. The window to the left belongs to the Conservative Club.

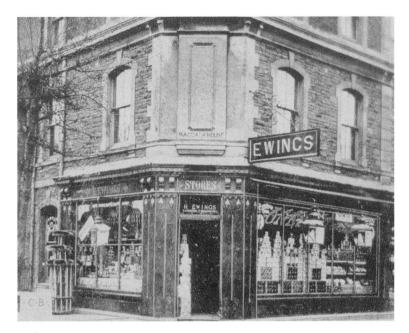

This comes from an advertisement of 1906 for Ewing's Stores on the corner of Queen's Road and Old Church Road. It shows what the original shop front was like. Many people remember the frontage with a semicircular carved wooden sign above the door, lost to rot some years back. It would seem from another advertisement that this and a few other alterations dated from around 1910.

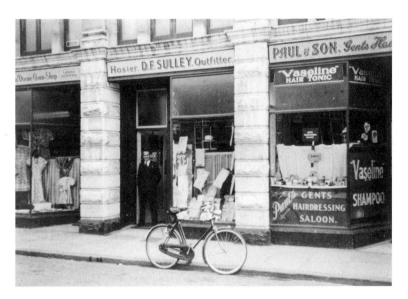

And what a change in the Cinema Row! Many small businesses treated this row as a sort of 'nursery slope', and moved when they needed larger premises. Don Sulley moved to No. 10 Old Church Road in the early 1960s when he'd tested the waters here. Brand names in stock were Tootal, Ship Shape, Klipper and Luvisca. Not brands one sees nowadays – what became of The Lorna Doone Gown Shop, I wonder?

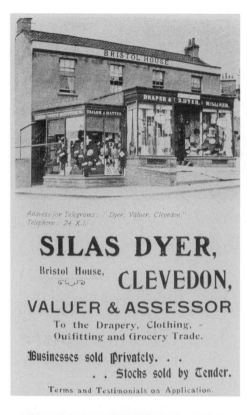

Address for Telegrams: "Dyer, Valuer, Clevedon."
Telephone: 24 X.I.

SILAS DYER,

Bristol House, CLEVEDON,

VALUER & ASSESSOR

To the Drapery, Clothing, -
Outfitting and Grocery Trade.

Businesses sold Privately. . .
. . Stocks sold by Tender.

Terms and Testimonials on Application.

Left: East Clevedon Triangle was once a shopping centre for that area, and Silas Dyer had a small empire of several shops there. His larger one was Bristol House, where as you see from this advert published before the First World War, you could be dressed from head to toe. At a later date, this became his grocery store, and the outfitting and drapery moved across the road to the shop adjoining Trellis House.

Below: I have to get the family business in! This prize-winning window display is in a style I call 'grocer's geometric' and was made by my grandfather, T.H. Lilly. He was in business in Kenn Road for fifty years in a shop at one end of Brighton Terrace, demolished in 1967. Flats for retired people were built on the site, between the Middle Yeo Path and the tyre replacement workshop.

Opposite above: Parker's Stores were at No. 43 Hill Road before moving across to No.14 at Handel House. In 1909, as you can see, they could roast coffee on the move! Handel House provided room for expansion, and he soon became one of the largest and most select grocers in the town. The wide range of stock encompassed wines and spirits, English and foreign fruit, tea and coffee, and many kinds of tinned goods.

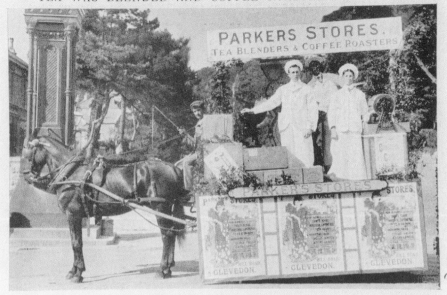

JOHN B. PARKER'S PRIZE WINNING DECORATED TRADE CAR

at the Clevedon Cottage Hospital Carnival, July, 1909.

TEA WAS BLENDED AND COFFEE ROASTED EN ROUTE.

The most up-to-date Stores in the Town. Best of residents and visitors.

PARKER'S STORES, 14, HILL ROAD, CLEVEDON.

Above: Dyer & Ward's business in Hill Road had cellars (now therapy studios) under Nos 45 and 47 which Ray Lumbard photographed just before the last war. This cellar is under No. 47 where wine and spirits were bottled. After corking the bottles with the machine in the centre, they were sealed with sealing wax, impressed with the Dyer & Ward stamp and then the shop's own labels were applied.

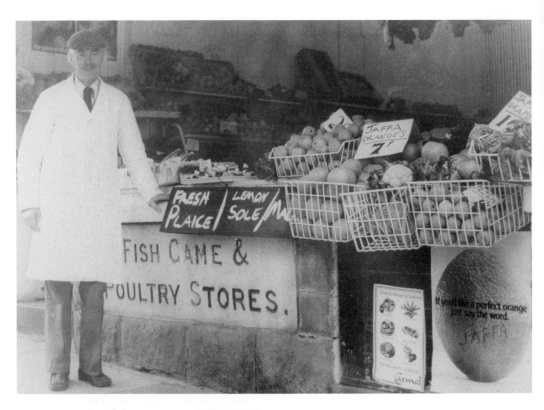

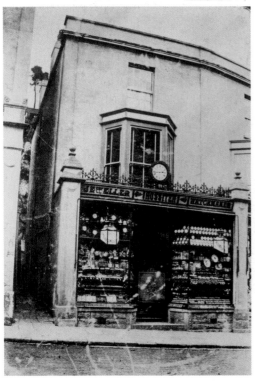

Above: Dainty underwear fills this window nowadays! We are still in Hill Road, at No. 75, converted to this frontage by George Brett. This is Horace Truman, about to retire in 1980 after eighteen years here. The shop was then very much as it had been for some ninety years, with its marble slab for keeping the fish as cool as possible. The front was shut by using large, heavy wooden shutters.

Left: At No. 79 Hill Road, Rossiter's has been running since 1870. The stock has broadened out to include cut glass now, as well as the original jewellery and watches. The clock and delicate ironwork on the shop front are gone, as are the handsome gas lamps which lit the window. This is the first of a row of three shops in Regent Place, now numbered 75, 77 and 79 Hill Road.

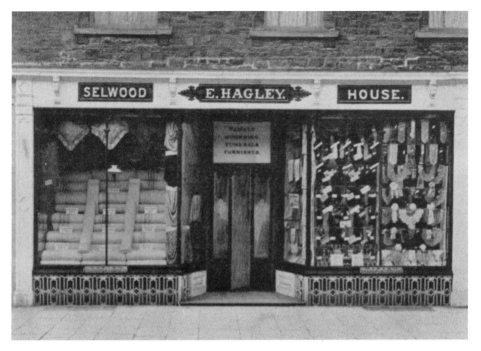

It was the shop boy's task to polish these brass grills below the windows of Selwood House, now Dunscombe's at No. 20 Hill Road. The shop was built and occupied by Mr Hagley in 1862, changing hands only in recent years after almost 140 years under Hagley's name. Like many drapery shops, the business could also fit you out with a coffin and mourning dress for sad occasions – cradle to grave!

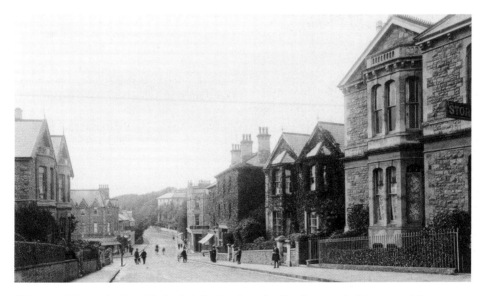

This part of Alexandra Road had relatively few shops in this photograph. It burgeoned between the wars, when many business people seem to have moved in and built shop premises in front of the villas on the right.

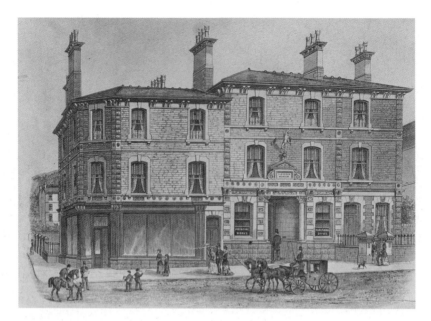

This Alexandra Road building was designed by the Weston-super-Mare architect, Hans Price, in 1879. The *Clevedon Mercury* had the central part for its printing works. They were based here until 1894, when they moved to the building now occupied by Barclay's bank at Sixways. The founding editor, George Caple, published this print in the *Clevedon Almanac*, and the small boys on the left are selling copies of his newspaper.

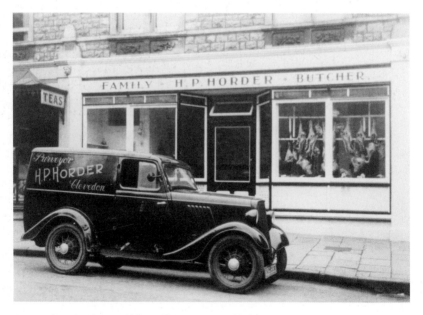

I remember this shop as Bill Griffin's butcher's shop in the 1960s, and it was an event when the van called to deliver the joint for the weekend. Bill bought the business at No. 15 Alexandra Road from Mr Horder, having learned his trade in Copse Road with Mr Coles. This photograph dates from the late 1930s.

Right: The Lovegrove family had several shops in Clevedon, this one in Marine Parade managed by the capable Clara Lovegrove, seen here around 1910. The shop was opposite the Pier with a large stock of souvenirs, postcards, sweets and tobacco. Lovegrove's also sold a range of crested china decorated with the Clevedon coat of arms and with their name stamped on the base of the pieces. The shops have since been converted into apartments.

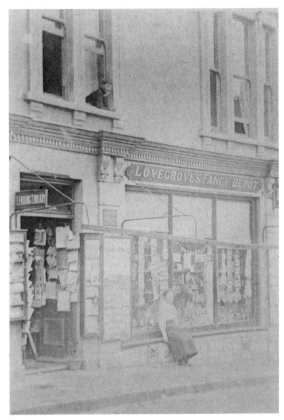

Below: In 1906, George Streetley was a baker and confectioner at Walton Park Restaurant in King's Road. This was the only house in King's Road in that year – it was more heavily developed with housing in the 1930s, and boasts a rare Edward VIII pillar box. Few people had telephones at this time, and from his shop he ran the telephone call office for this area of the town.

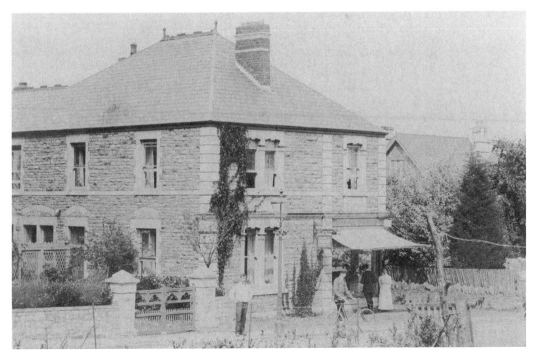

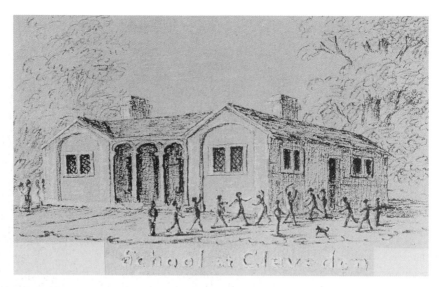

I believe this is unique. It depicts the original 1834 Parish School in Clevedon first rated in 1835 as 'Parish Scool' (sic) – much needed! It was in Old Street, by the present fire station, and the first master was Edward Hardin. Clevedon was growing so quickly that extra ground was given in 1858, and a new school, now Holdland House, was built here, incorporating parts of the 1834 building.

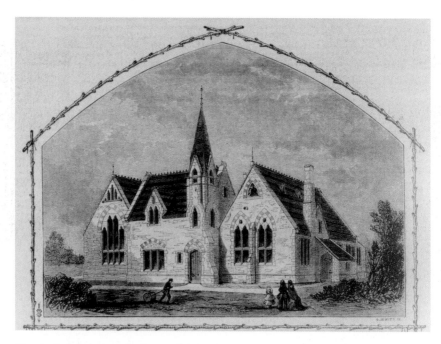

Here is the impressive new National School of 1858 in Old Street by the present Fire Station, designed by Pope and Bindon in the Venetian Gothic style. The boys were housed to the left, and the girls to the right, in rooms measuring 45ft x 19ft, divisible with a curtain or folding door. Mr Henry Tipper lived in the master's house between the two large classrooms. 200 children could be accommodated.

This pretty building now serves as offices for Clevedon Town Council in Old Street. There was originally one large school room when the Infant School was built in 1846, but more rooms have been added over the years. The teacher lived in the small house with the two ladies in front of it adjoining the school which is on the right.

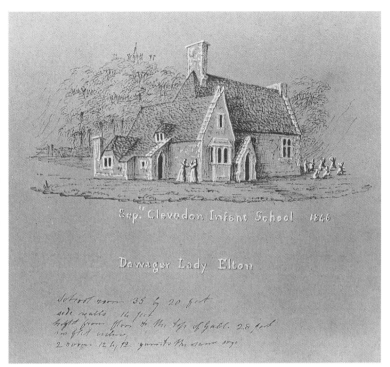

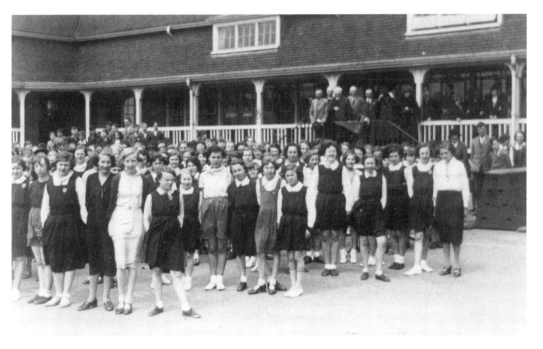

Here is Highdale School on Empire Day, 1935, when it was the Senior School under headmaster 'Crammo' Croft. It became Highdale Junior School in 1963, when the present community school opened in Swiss Valley. David Bryant Clevedon's World Champion bowler was one of the teachers there. It is now St Nicholas Chantry, named after a thirteenth-century chantry of St Nicholas at nearby Highdale Farm.

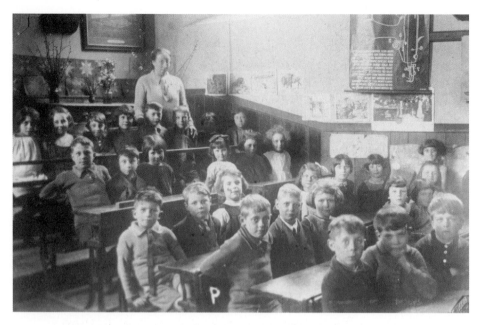

In Chapel Hill on the site of Chapel Court, this was Clevedon's first Non-Conformist chapel in 1827. It became a British School, (Non-Conformist), after a new chapel was erected in Hill Road in 1855. This was taken in the 1920s and in the second row from the back, second from the left is Bill Griffin. Another boy known is Bert Puddy, in the front row on the far right.

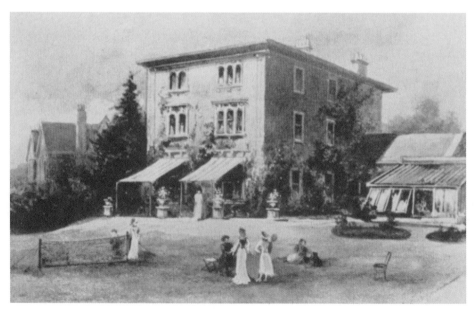

The building opposite Christ Church that we know today as Belmont began life in the 1860s as Duncan House, a private school for girls. By 1903, *Mate's Illustrated Guide* was promoting it as a 'School for the Daughters of Gentlemen,' where young ladies could learn to play badminton and tennis on the school's own courts, as well as benefit from the tuition of the highly qualified resident mistresses.

In the early part of the twentieth century, Clevedon was still a highly popular place for small private boarding schools like this one. Hawkesbury was in Linden Road, near the Prince's Road junction, and run by the Misses Coleman. Girls of all ages came here to learn how to cook, manage a household and do laundry work as well as following the usual course of study in general educational subjects.

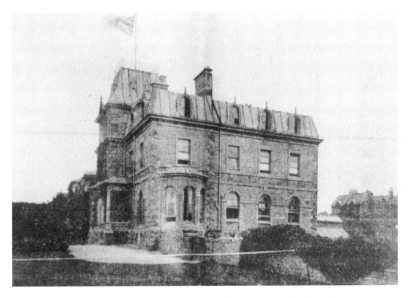

Lewesfell stood in Elton Road where Pembroke Court was built in the 1970s. It was a boarding school for 'Young Gentlemen' run by Eustace Button, who first worked as an assistant schoolmaster for the Revd Macy at his school on The Beach. Taking over that establishment, he moved it as Clevedon College to Lewesfell, his brand new house, in 1857.

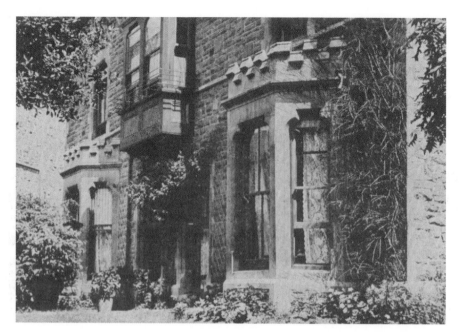

This is the Lawn School in Madeira Road in 1903, when an advertisement tells parents that, 'The principals have an excellent connection in India, Ceylon and other places.' It is a pair of houses today, and would have been quite a good size for the children who attended here, mainly girls of a wide age range with boys of pre-preparatory school age. The school's next home was Elmhurst in Albert Road.

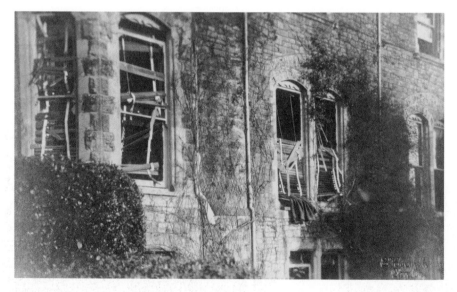

The school later shifted next door to this pair of houses, Clevelands and Rosemont, renamed The Lawn, together with Rycote Lodge next door, renamed Lawnside. This shows damage caused by a gas explosion during the First World War, described by Mollie M. Kaye in her autobiography. Fortunately, a servant fetched Mr Louis Neads from his premises nearby and he turned off the gas at the main. Repairs were made soon afterwards.

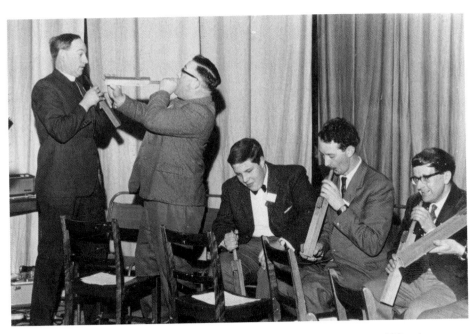

There were great rollickings at Christ Church after the organ renovation in 1964! The players of the various pipes. From left to right: Revd Keith Weston, Reg Marks, John Senior-Stern, Charles Brass, John Cadogan. The renovation was a project to commemorate the church's 125th anniversary, with organ work by Percy Daniel & Co. and electrics by Major Low. Reg Marks and Bill Bryant replaced the oak flooring where needed.

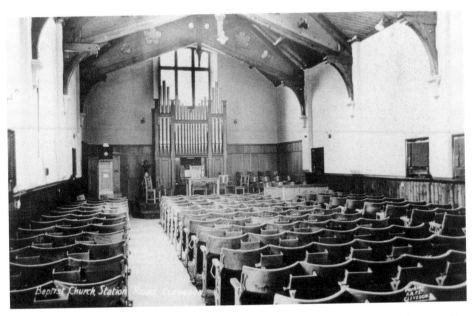

Here is a wonderful view of the interior of the old Baptist church in Station Road. The rows of linked 'tip-up' seats are very practical.

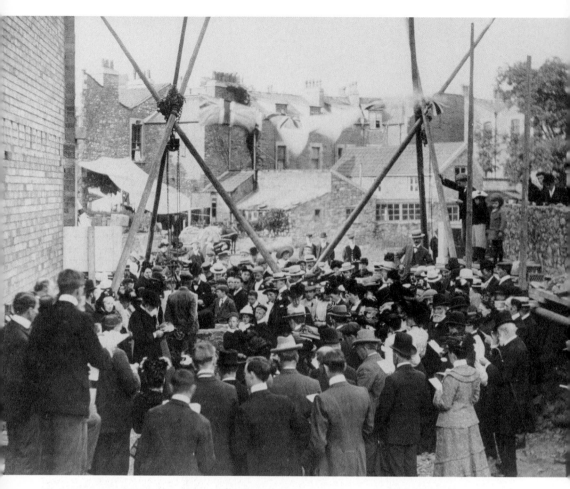

Station Road was laid out in 1897 and the first row of shops with integral accommodation followed in 1900. This, the 'church' side of Station Road, was built four years before the opposite side. The photographer is looking across to the rear of the Old Church Road shops from the front of what was then the Men's Meeting Rooms, now the site of the Baptist church. The foundation stone is here being laid for these rooms in 1903. The Baptists began to meet here in 1922, buying the building in 1924. Their new church was built here in 2006 – the bold design enhances Queen's Square.

Opposite above: It's a surprise to see Copse Road chapel without the Sunday School, which was built in 1877 to the left side of Foster & Wood's original chapel of 1851.

Opposite below: Foster & Wood designed this chapel for the United Reform church in 1855. It is an attractive building with its elegant spire. Now converted into apartments, its character has been retained. To the right is Olden Lodge, a building I call the 'gingerbread house'! It is one of the prettiest of Clevedon's Regency houses. Keith Mallory points out in *The Bristol House* that it is our only Gothick building.

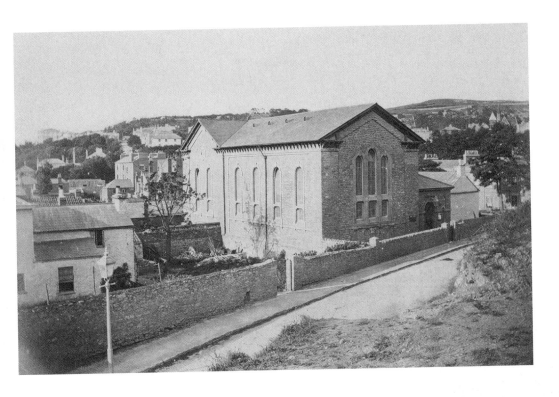

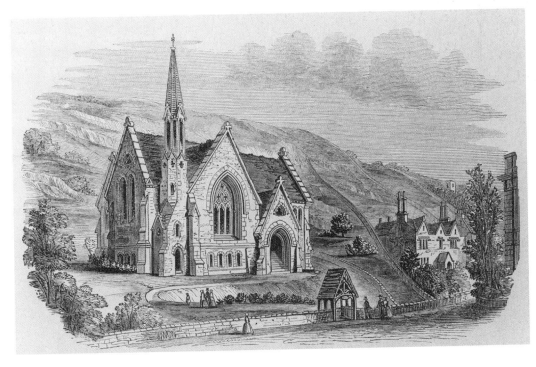

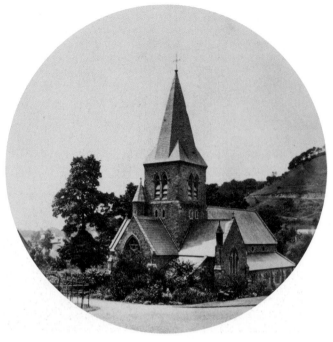

The broach spire at All Saints always reminds me of Swiss churches – and in Swiss Valley this is very apt. Built in 1860, it was erected for Sir Arthur Elton and Dame Rhoda Elton to a design by C.E. Giles of Taunton. In due course, other Eltons made their own contribution, notably in the form of Elton Ware candlesticks from Sir Edmund whose Sunflower Pottery flourished from 1880 until 1920.

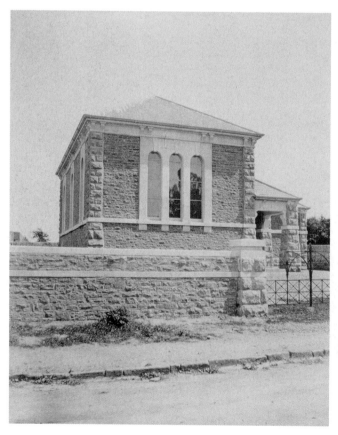

Here is an almost unrecognisable picture of the Friends' Meeting House built in Albert Road in 1867. The building is now obscured by large evergreen trees, so it is good to have a clearer look at it as it was soon after its construction.

At St Mary's church in Walton St Mary, this older stonework can still be discerned in the present building. This is what remained of the church of St Paul, serving the settlement of Stoke-super-Mare which predated Walton St Mary. The villagers moved to Walton-in-Gordano leaving the church marooned, and after a new church was built in Walton-in-Gordano, the old church fell into total dereliction.

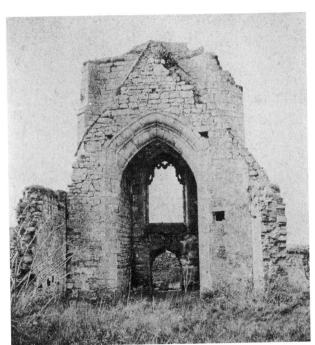

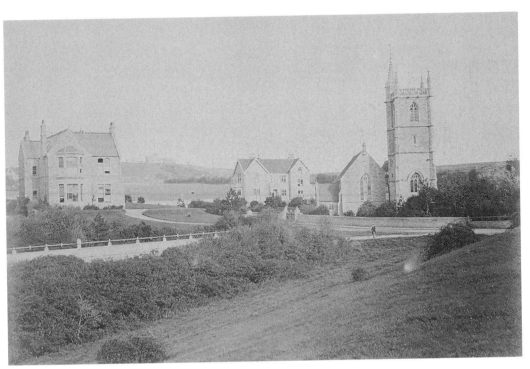

By 1855, the Miles family were selling building plots on the parkland around St Paul's. Plots sold rapidly, and houses were quickly built to form a suburb with the need for its own church. In 1870, St Mary's church was consecrated, built onto what remained of St Paul's. The house on the left stands at the beginning of Bay Road and that nearest the church is in Channel Road.

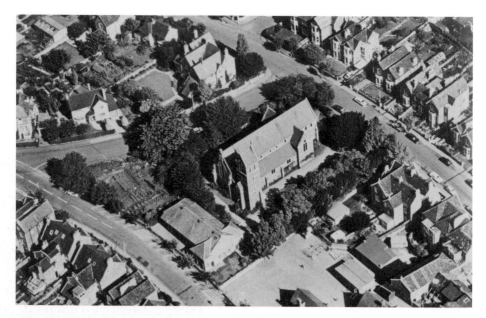

What a large plot St John's was built on in 1878. Part of it is laid out in well-tended allotments, adding further charm. The design is by Butterfield, a favourite of the late Sir John Betjeman, who paid a visit to see the copper altar frontal of 1911 made by Barkentin & Krall of London. Due to Sir John's interest and the work of Revd D.P. Rundle, the frontal was restored.

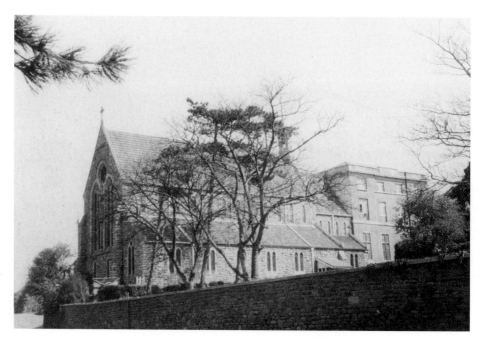

In 1882, an order of friars left France and bought the old Royal Hotel, shown to the right, which had fallen into disuse. Here, they lived and worshipped. They began with a congregation of five in the town, and in five years built the church of the Immaculate Conception. The hotel was the speculative venture of William Hollyman and George Newton in 1825.

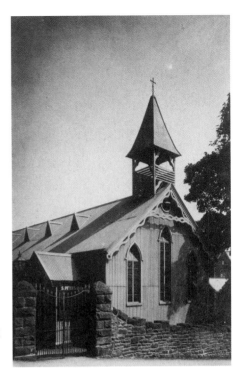

This 'tin tabernacle' stood on the present car park of St Peter's church. It was purchased second hand from Margate, and arrived dismantled on the train in 1899, fully equipped. The corrugated-iron walls and roof were matchboard-lined; its windows were Cathedral glass. The present church, consecrated in 1960, was paid for by Dame Violet Wills of the Bristol tobacco family. The architect was R.E. Beswick of Swindon.

This is a useful guide book illustration! It is the old Methodist chapel in Kenn Road, surrounded by fields in 1949 and at that time the last building in the road. It was adapted from two redundant army huts, the building work driven by the faith and enthusiasm of Mr Edmund Shopland. Land was left vacant between the church and the road for a new building, put up in 1990.

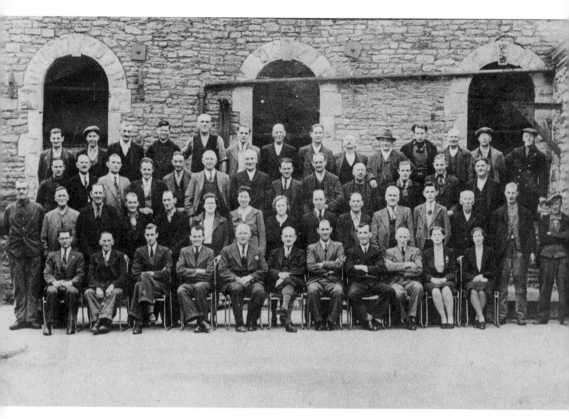

This photograph was taken in about 1941 of the gasworks staff, at the Clevedon & Yatton Gas Co. in Moor Lane.

Back row, left to right: Mr Howard, Roy Bray, Arthur Puddy, George Lawton, Sid Davis, Bob Cunningham, Ern Bray, Les Blake, Walt Amesbury, Charlie Youde, Bill Nicholls, Harry Lester, Percy Dallimore, Alfie Foster. Third row: Bill Tooze, John Neath, Bernard Blackmore, Bill Reed, Les Gillard, Gus Neath, Charlie Thorne, Fred Bray, -?-, Bill Amesbury, Len Baker, Bill Durbin, Ern Bray. Second row: George Dorse, George Hobbs, Ted Baker, Harry Baker, Jack Selwood, Joyce Palmer, Miss Hewett, Mrs Bray, Sid Montgomery, Tommy Hall, Bill Hack, Peter Ganniclifft, Charlie Long, Tom Gooding, 'Carrots' Barrett. Front row: Geoff Dodge, Arthur Bray, John Anning, Ken Langford, S.B. Jones, J. Harger Pye, Ern Coles, W.J. Hurn, Ken Richards, Gladys Yandell, Miss Faulkner.

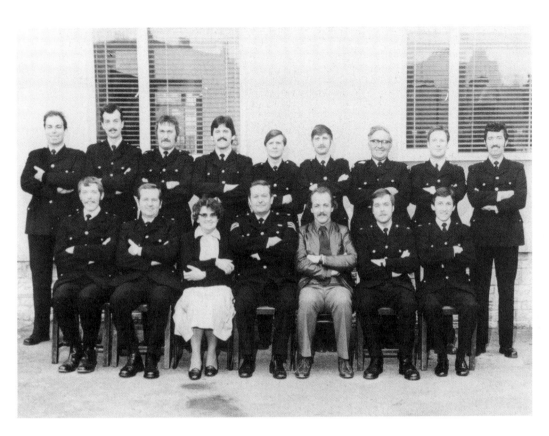

Above: Here is Clevedon's Police Force in the 1980s. Front row, left to right: Darren Blesard, Derek Paxham, Irene Martin, Sgt Martin Ward, Phil Kidner, Steve ?, John Colley. Back row: Andy Gray, Brian Book, Michael Barrett, Bob Turner, Graham Tomlinson, Malcolm Bache, Phil Ellis, John Horrobin, John Lucas.

Right: Phil Ellis is in winter mode as traffic warden outside Malvern House in Hill Road. This branch of Boots was the last of a long line of chemists' businesses to occupy the shop, built in the late 1860s, including Thomas Grant and James Shepherd. A stone shield on the frontage said 'Established 1847', but this referred to a business that moved there, not the building itself.

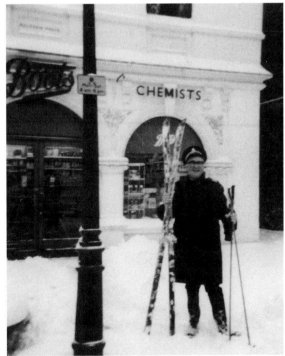

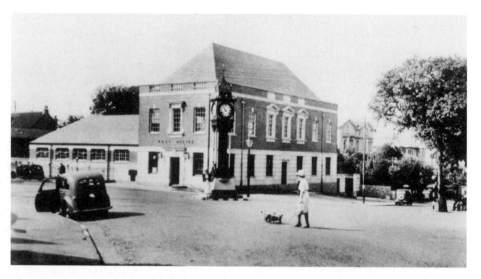

Clevedon's Post Office was in Rockleaze in Hill Road, until the Marquess of Bath opened this building in September 1938. The first stamp was sold by Mrs Ian Orr-Ewing to Mrs R.G. Burden, and the Marquess sent the first telegram to the Postmaster General. Tea was served after the votes of thanks had been given, and visitors were allowed to tour the building.

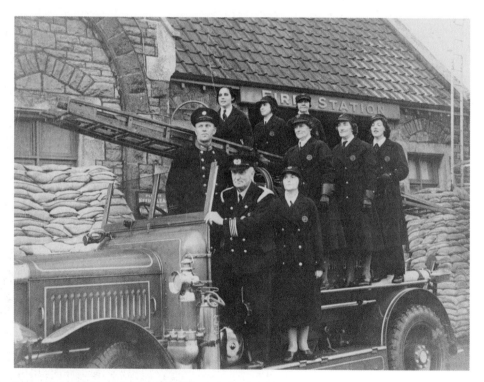

Taken during the last war, this is the Women's Auxiliary Fire Service. Mr E. Shopland, the driver, is standing by the ladder. The three ladies at the back are Miss J Hain, Mrs A. Osborne and Mrs Nicklin. In front of the ladder are Mrs Light, Mrs R.Virgo and Miss Hagley. The gentleman at the front in charge is Mr E. Dawes, with Mrs G. Archer next to him.

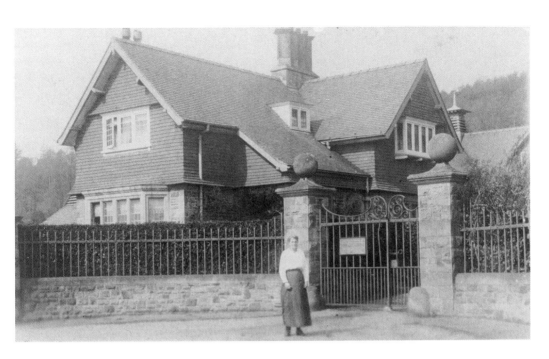

Above: It is curious that the original Clevedon Waterworks Co. was based in the present fire station building! However, the company moved to these premises on the Tickenham Road in 1902, designed by Bristol architect H. Dare Bryan in the latest style of the day. In 1953, Bristol Waterworks Co. took over and replaced the steam turbine and centrifugal pump with electrical submersible well pumps, and added a softening plant.

Right: Locally called the *Clevedon Lightship*, this was moored off our coast by the English and Welsh Grounds. It was a popular calling point on the trips run by the local boatmen, and the crew enjoyed the visits. After this one went out of service, it was replaced by the last wooden lightship to be used off the coast of Britain, the *John Sebastian*, still maintained in the Bathurst Basin in Bristol.

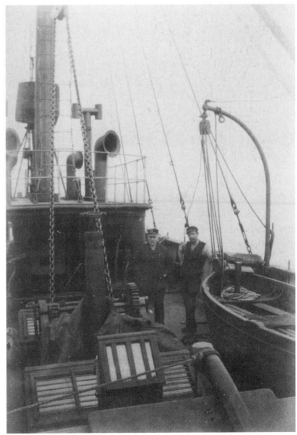

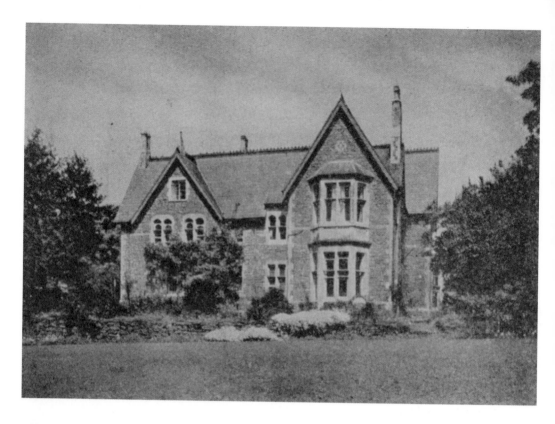

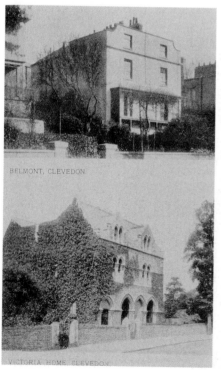

BELMONT, CLEVEDON.

VICTORIA HOME, CLEVEDON.

Above: Garstons in Prince's Road was a Christian Alliance (of Women's Groups) Holiday House, charging 8 guineas per single room per week. Guests were expected to bring their own towels and serviettes, and make their own beds. No smoking or card playing was allowed in the house or grounds. These holiday houses allowed single working women to find economical accommodation with congenial company.

Left: These two houses, Belmont and Victoria, were run as convalescent homes: Belmont, above, housing the ladies, was the original name of this Regency house, now Highdale Court flats. The Victoria Home for gentlemen was in Hill Road, and is now converted to Knightstone Flats.

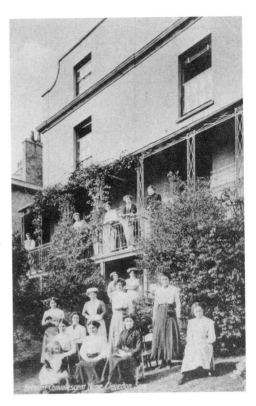

Right: Here are some of the Edwardian occupants of the original Belmont in Highdale Road, out enjoying the air and the fine Mendip views. This ladies' convalescent home later moved to the former Duncan House at the top of Chapel Hill opposite Christ church and took the name 'Belmont' with it.

Below: Men recovering from illness could be accommodated in the Victoria Home in Hill Road. The home faced south and backed onto Herbert Gardens, with a comfortable conservatory at the side for the frailer patients, or for use in inclement weather. On warm days, as you can see, there was pleasant seating in the garden.

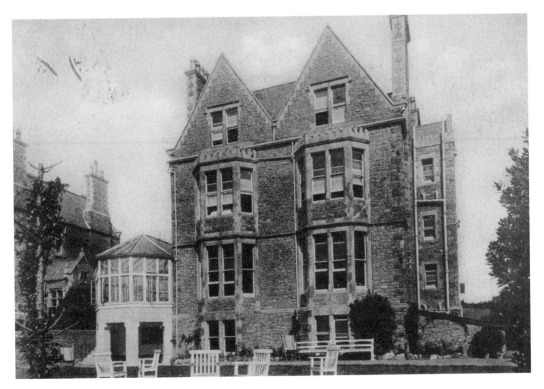

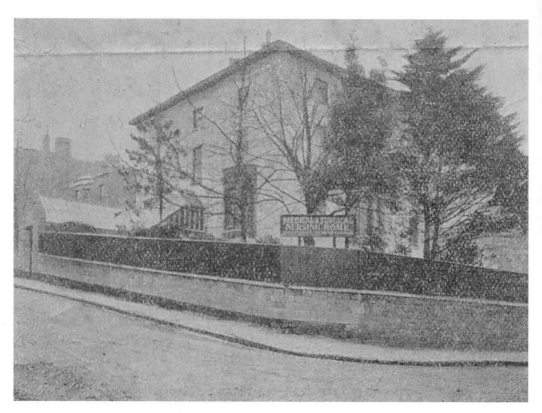

This is Peterhurst, built as Albert House in 1832. By the early 1900s it had become a nursing home, taking medical and surgical patients. During the war, it became a maternity home for serving men's wives. Many people come back to see their birth place only to find it was demolished in the 1950s. It stood opposite St Peter's church on the corner of Alexandra Road and Copse Road.

five
Chaos and Change

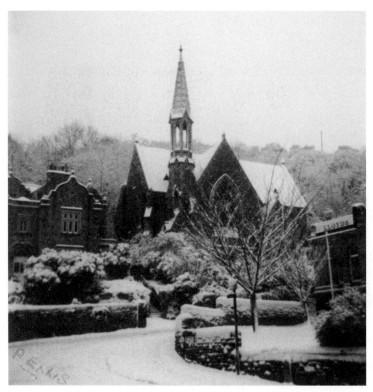

At first glance this could be Swiss Valley – but it is the Congregational church in Hill Road, captured by Phil Ellis in the 1970s. Snow has a curious effect when photographed making the light bright but sunless.

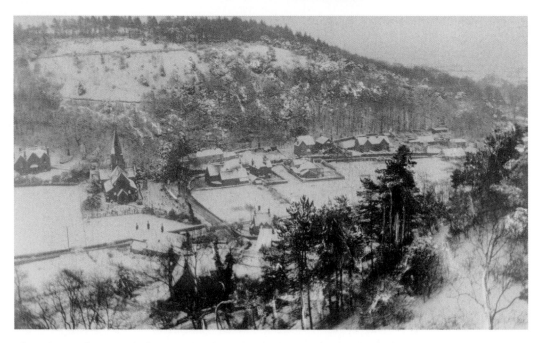

This is Swiss Valley around All Saints' church in a lovely photograph taken by the father of the late Revd Noel Sandford in about 1903. The Portishead stretch of the Weston, Clevedon & Portishead Light Railway has yet to make its way up the valley, or we would be able to pick out the line in this whiteness very clearly.

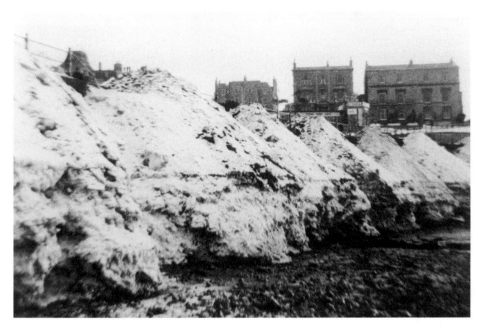

This was the scene on The Beach when the sheer volume of snow on the roads caused the council a huge problem in the winter of 1962/63. The snow was tipped onto The Beach where the mounds of it were high enough for the council trucks to reverse up them to the top and tip more snow straight over onto the pebbles below. The rates went up to pay for this!

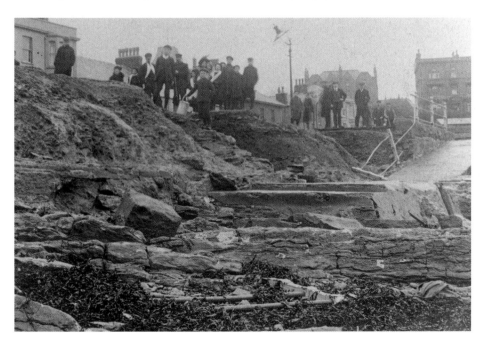

The aftermath of a storm which ripped up the sea wall along the Channel coast on 16 December 1910 – somehow I doubt that the crowds turning out to watch the high tide with a strong wind behind it would have been safe in this one! This is always a vulnerable part of The Beach.

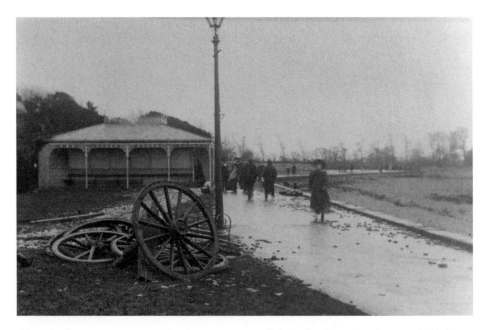

Above: In the same storm, extensive damage was caused along the Green Beach too – the shelter seems to be unscathed, but pebbles lie on the footpath, and some poor soul has been able to rescue only the wheels from his cart, seen here leaning on the remnants of a bench.

Below: Mr Lippiatt was a very enterprising local photographer, always on hand to record local disasters, rapidly making them into postcards. Here the September storms of 1903 have done great damage, destroying every boat and damaging bathing machines on The Beach.

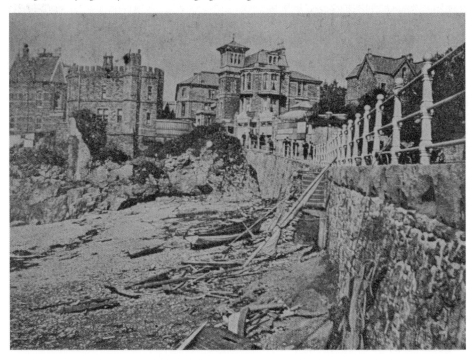

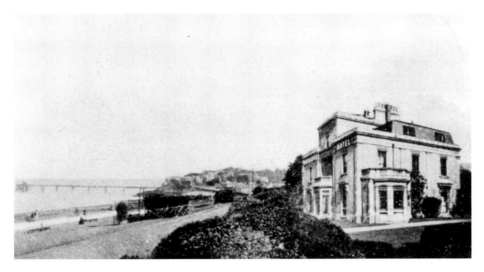

Above: A view of Oaklands between the wars. It was demolished in the late 1960s, and now flats and small houses are on the site. As a private house before the First World War, it was owned by a branch of the Wills tobacco family of Bristol. During that war the family allowed its use as a Red Cross Hospital, where many British and Allied servicemen convalesced.

Below: Another of Elton Road's since-demolished houses was The Hawthorns, run as a hotel for some years before the war, and previous to that occupied by the third White Rajah of Sarawak, a member of the Brooke family. Three of them were Rajahs from 1842 until Sarawak was ceded to the British Government in 1946. The third Rajah and his brother had been pupils at Walton Lodge School in Walton St Mary.

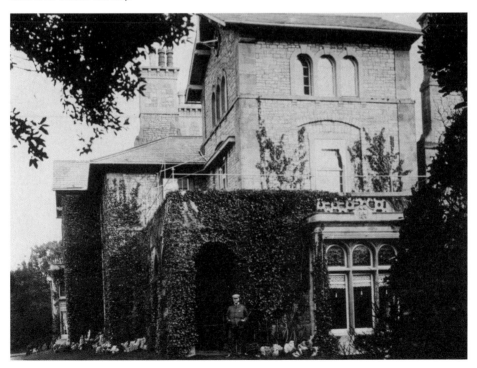

This was work on a road widening scheme in 1928, captured by Ursula Kenway, *née* Eddy. There were no mechanical aids, it seems, and all of the lifting and shifting was done by hand. The road is Hill Road, where at the seaward end the Friary wall had to be moved back to allow for better access to the awkward corner there.

At this point further up the road, the Friary wall was not a retaining wall, so there would be a lot less digging involved. However, this picture graphically illustrates the amount of stone to be moved.

Right: The Market Hall of 1869 in Alexandra Road was sold to North Somerset Electric Supply Co. in 1923 after the income from stalls failed. It next became a brewery until 1937, when plans were submitted for a cinema – they were turned down. Following the closure of Trask Brothers' Beatrice Engineering works, Brian Williams restored the building in the 1980s.

Below: The old dispensary was built in 1865, ten years before the Cottage Hospital next door was converted from Highdale Farm barn. Hans Price, an architect from Weston-super-Mare, was commissioned by Sir Arthur Hallam Elton to design the building, replaced in recent years with a more spacious, modern unit.

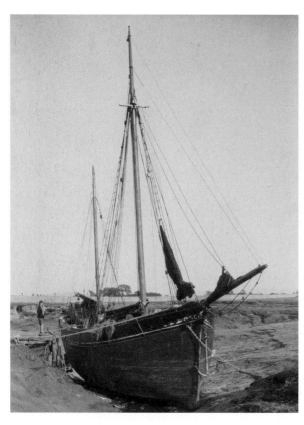

Left: Change came to Clevedon Pill when the ketch *Bessie* from Barnstaple went out of commission. She was the last trading vessel to use the Pill and Grahame Farr has described her long life of bringing gravel to Clevedon for the building sites of the 1930s. Captain William Rowles, Master Mariner, scrapped disused wooden ships at the Pill for many years.

Below: Strawberry Hill Lane was bare of trees in the 1880s, whereas now there are woods on the slope to the right, on the flank of Strawberry Hill. The track is one of the old ones leading up to Clevedon Park through the Fir Woods, still an attractive walk today.

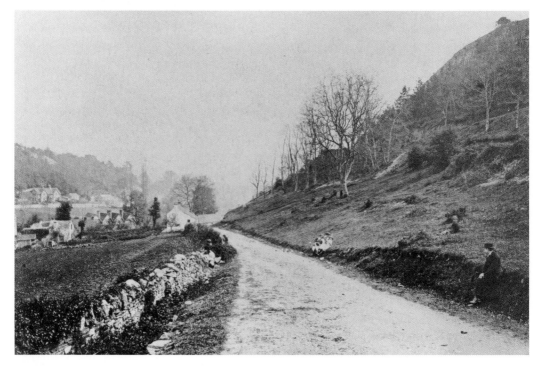

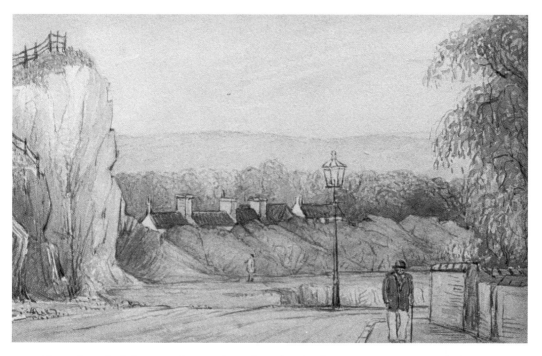

The rocks to the left are near the Bristol Hotel in Chapel Hill. In 1895, quarrying continued in Highdale Avenue and these rocks still separated it from Chapel Hill. The rooftops are in Limekiln Lane, off Old Street. The view is from Lower Linden Road and Chapel Hill drops away to the right. The wall on the right belongs to Knapp House, demolished for Western Court flats in the 1960s.

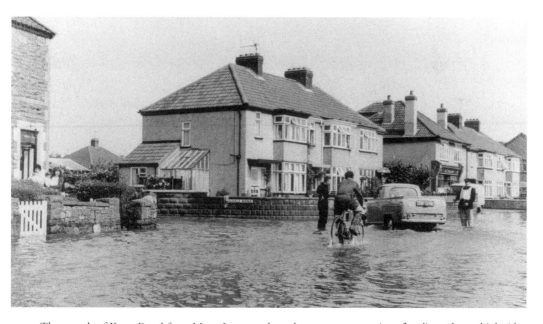

The stretch of Kenn Road from Moor Lane southwards was prone to serious flooding when a high tide made it impossible for the Middle Yeo to take water away from the drains and out into the Channel. Occurrences like this appear in photographs from 1907 onwards: this one dates from the late 1960s.

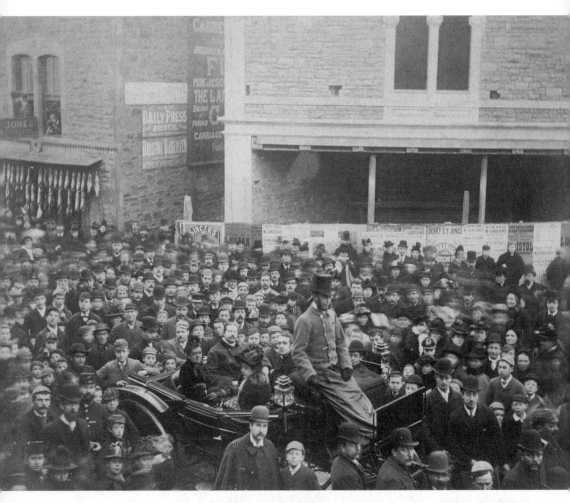

Strong local interest was roused by a libel case against Sir Edmund Elton by the Revd Vicars Foote! Sir Edmund won, and was so popular in the town that his carriage horses were unhitched and the bowler-hatted gentlemen seen here towed him home. This was in 1890, soon after Thomas Hill had bought the building site beyond the crowd. Mr Hill's work is in progress, awaiting its shop windows – now the Triangle Post Office. W.H. Jones in the shop to the left was a fishmonger and game dealer, whose premises had been built for the family in 1870. This shop was later occupied by Burnell Bros, saddlers.

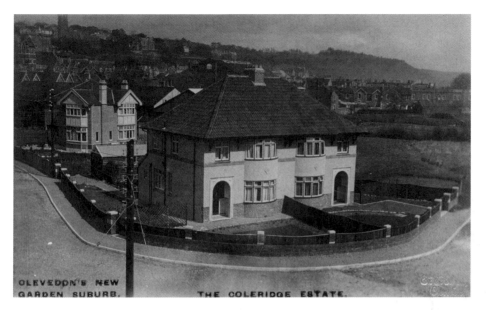

Building was nicely under way when this postcard was printed to publicise the new Coleridge Estate. Builders of good local repute such as Jack Tarr and Burston & Hawkins were involved in this development. Building began in 1930, and continued at considerable speed, with houses planned for Mr Tarr by Donald Long, whose brother Hedley was also a noted local builder.

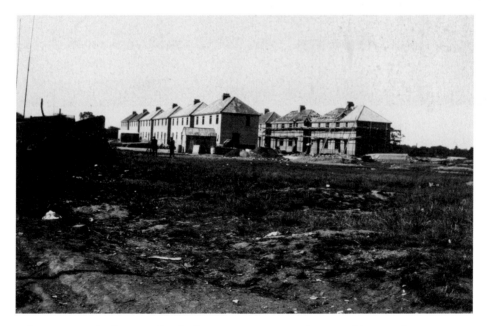

Hillview Avenue has been totally rebuilt in recent years. Here the original houses of 1928 are being built behind Kenn Road. This area made up part of Shopland's Brickworks and after the works were dismantled, belonged to the Yeates family. Locally named 'Yeates Field' it was used often for performances by Col. Sanger's touring circus, and his parades through The Triangle to the field were led by a pygmy elephant.

Bibliography

Clevedon Civic Society Local History Group publications, all available from local bookshops:

Clevedon: from the village to the town, 1981
The Annals of Clevedon, 1988
Clevedon Past, 1993
Clevedon's Social and Industrial Heritage, 1998
Clevedon: Clubs, Quarries and Cash, 2002
Clevedon at War, 1939-1945, 2005

Rob Campbell, *Clevedon's own: The First World War, 1914-1918*, Clevedon History Publications, 2004
Nigel Coombes, *Striding boldly: The story of Clevedon Pier*, Clevedon Pier Trust Ltd, 1995
Grahame Farr, *Somerset harbours*, Christopher Johnson, 1954
Haslam, Malcolm, *Elton Ware*, Richard Dennis, 1989
Mollie M. Kaye, *The sun in the morning*, Viking, 1990
Keith Mallory, *Clevedon Pier*, Redcliffe Press, 1981
Keith Mallory, *The Bristol House*, Redcliffe Press, 1985
Christopher Stone, *Clevedon's Sporting Heroes*, 2004

And my own previous books.

I can recommend the website 'Clevedon-Civic-Society.org.uk' for those interested in the town and its history.

If you are interested in purchasing other books published by Tempus, or in case you have difficulty finding any
Tempus books in your local bookshop, you can also place orders directly through our website
www.tempus-publishing.com